CONTENTS

CW00721652

ENGLISH HERITAGE

INTRODUCTION

This fascinating collection of images shows people at work in a wide range of occupations from Victorian times to the recent past. Through these images we get glimpses into the everyday world of people with a vast array of skills. They also record industries that once employed large numbers of people and played prominent roles in their local communities, at a time when England was a leading supplier of manufactured goods to the rest of the world. In many cases these industries have changed out of all recognition – this selection of images reflects many of these changes.

By 1857, when the earliest image in this collection was taken, Britain was already an industrial nation with most people living in towns and cities and working in factories. Children above the age of eleven often worked full time and many industries such as the textile and pottery trades relied heavily on women to make up the workforce. Many processes had been mechanised but a lot were done by hand and required great skill. Some trades – for example nail making and jewellery working – were still carried out in small workshops, often in back yards, until well into the twentieth century.

Most places had a local industry or one major employer and people worked there for life; sometimes several generations from one family worked in the same place. If they moved they moved to other places based on similar industries – from Wolverhampton to Corby for steel working or railway engineers between Swindon and Crewe.

However, in the 1950s and 1960s many towns lost long established industries like brewing, victims of mergers and economies of scale.

Traditional skills in manufacturing, shipbuilding and engineering are recorded. Eileen Deste's photographs of workers in the pottery and textile trades (page 7) are all individual shots taken from sequences of images showing these entire processes. Some skills such as puddling clay to line canals date back to the very start of the industrial revolution, well before photography was invented, but are shown in Henry Taunt's early twentieth-century images of the restoration of the Thames and Severn canal.

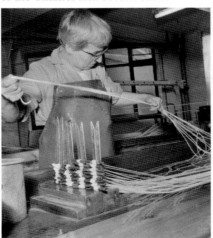

The two World Wars resulted in increased mechanisation and the rise of new technologies along with increasing competition from other countries.

There was a shift in the nature of work from heavy industry to smaller scale scientific and technological industries, manufacturing electrical goods and computer components rather than ships and locomotives. The 1970s saw the establishment of the service industries that now play a major role in the economy.

Those families that remained in rural areas generally continued to work in a less mechanised manner in farming or in small workshops attached to their homes. Even agriculture, however, experienced a steady increase in the use of machinery which displaced manual labour. Many traditional rural trades and skills, such as thatching, stone carving and blacksmithing, were all but lost. Kept alive by just a few craftspeople, they were only valued again and revived in recent times. Some of the jobs shown, such as preparing gut for stringing tennis racquets and glass blowing, have always been highly specialised.

There have always been service industries, ranging from the Victorian waterman in Oxford and the cab driver in London through to motor mechanics in the 1950s. Many people found employment servicing the newly emerging transport-related industries. The 'white collar' jobs in offices such as those of *The Morning Post* are shown alongside the 'blue collar' manufacturing jobs. Domestic service continued as a major employer of both men and women until the Second World War.

£ 3.99
9/32

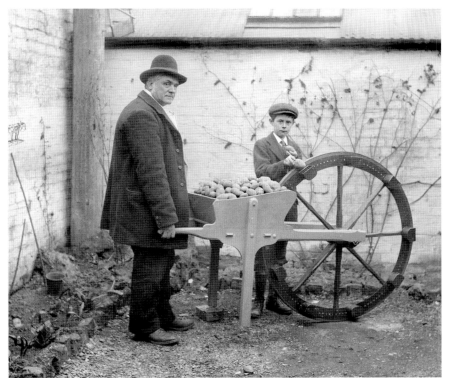

The pride that people take in their work is evident in many images, from the team of postmen and women to the farmer with the potato planter he has invented (page 68).

Above all it is the people and the different experiences of working that pervades this collection: the men at Butlers Wharf queuing for their pay; the overseers distinguished by their bowler hats; the working clothes ranging from leather aprons to the smart uniforms of the lift operators and usherette; the ladies at Mrs Walsh's factory in Macclesfield with their assorted chairs grouped companionably around their sewing machines.

Some people are said to 'live to work' and others to 'work to live'; whatever their attitude, work generally plays an important role in their lives.

Mary Mills
Education Officer, NMR

Vibrant street scenes evoke memories of people working in ways that were once familiar but have changed or even disappeared over the years: the porter from Billingsgate walking down the street carrying a fish on his head; tradesmen posing beside their horses and carts; a policeman wearing white cuffs directing the traffic; the itinerant 'bodger' mending a chair seat on the pavement; market traders selling everything from clothing to sheep.

Some of the working conditions pictured would not be allowed today. The herring girls gutting fish on the dockside while middle-class tourists look on, and the men cleaning the chimney in Hackney, show how things have changed in this respect. Older, more relaxed attitudes to Health and Safety are also reflected in many of the images such as the building of Brunel's steamship the *Great Eastern* or of bell casting.

MANUFACTURING

"I WENT to work in a cotton mill. I started work as a doffer. I used to take tops off bobbins and fill them with cotton and then take them off. The wool started as fleece and by the time it left the mill it was ready for weaving. One day it was my eighteenth birthday and I was wearing high heels and I slipped and lost my little finger. It took me 12 months to get £15 compensation."

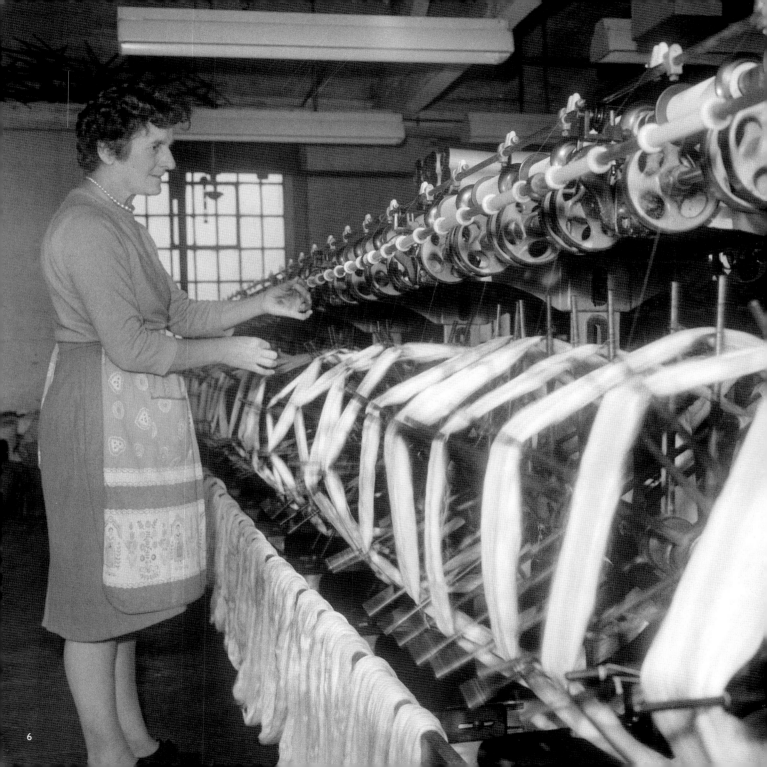

A woman works a machine to spin cotton onto reels at Bentley and Whittle Silks, Wellington Mill, Leek, Staffordshire.
Eileen 'Dusty' Deste *1960-1974*

Processing gut to make racquet string or sausage skins. West Yorkshire or East Lancashire.
Eileen 'Dusty' Deste *1960-1974*

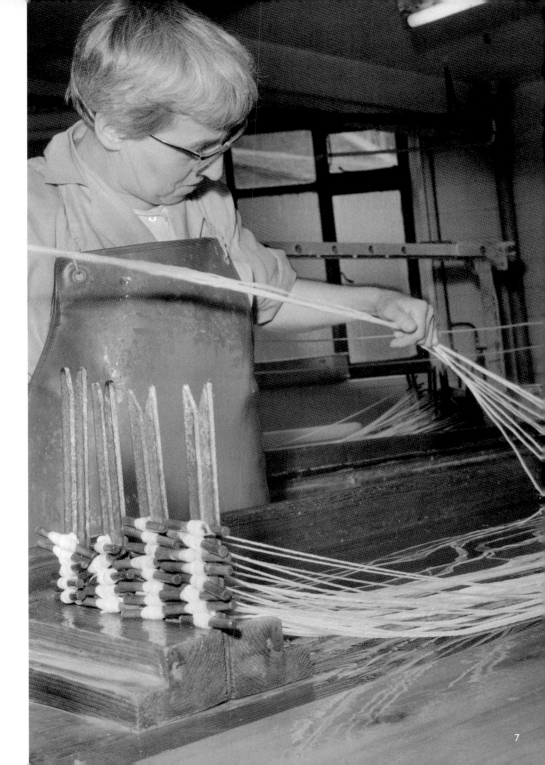

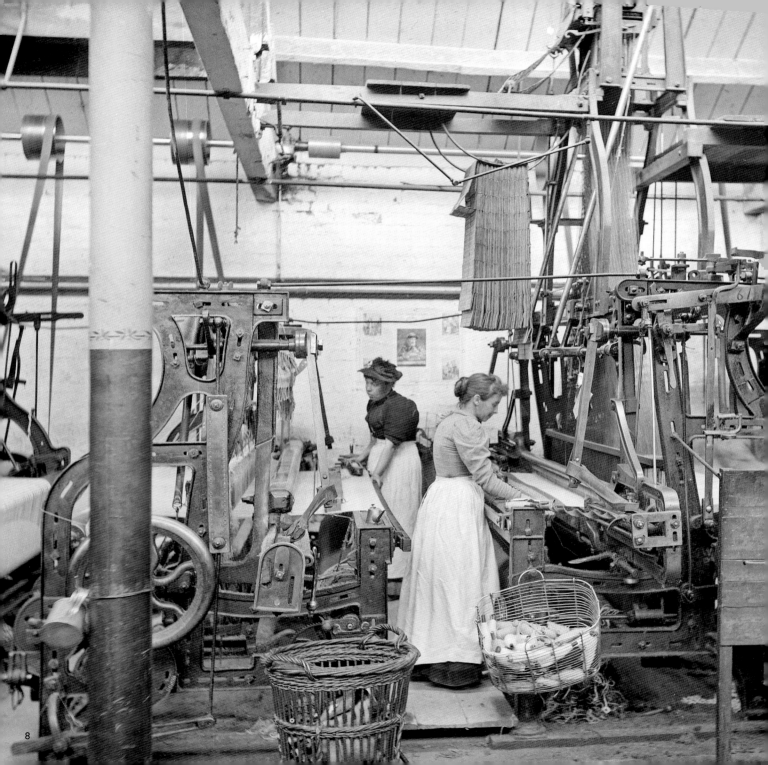

Women work large power looms
at the Early Blanket Factory,
Witney, Oxfordshire.
Henry Taunt *1860-1922*

Men at work in the print works
of the *The Morning Post*, Aldwych,
Westminster.
Bedford Lemere *November 1920*

Typesetters at the Church Army
Press, Cowley, Oxfordshire.
Henry Taunt *1860-1922*

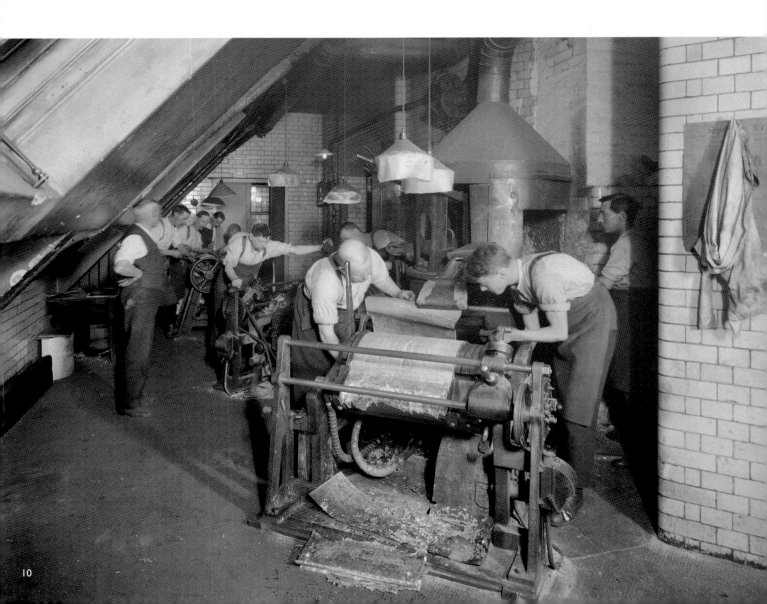

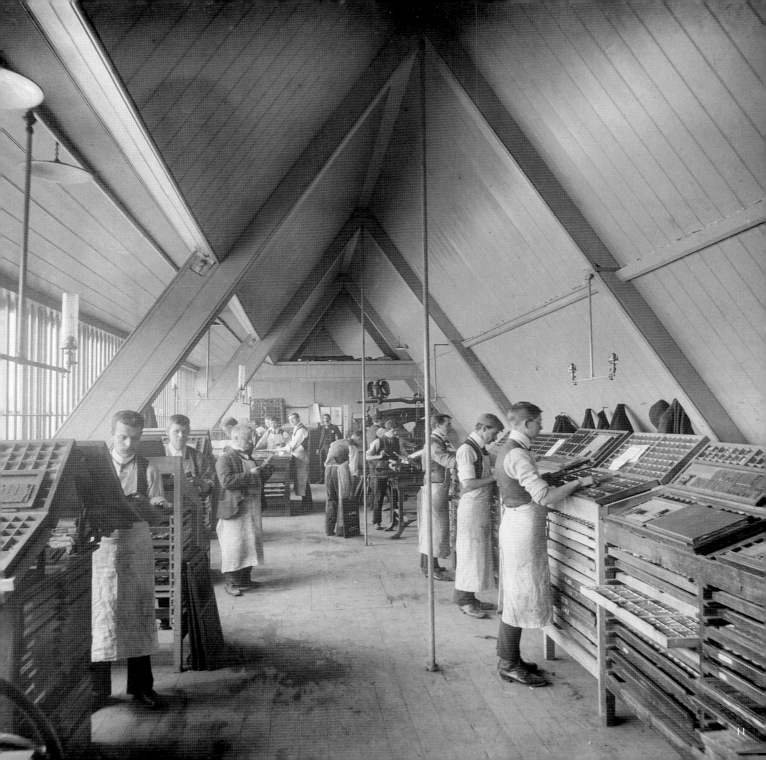

Workers at Gross, Sherwood & Heald's paint factory at Jenkins Lane, Barking, London.
Bedford Lemere *1910*

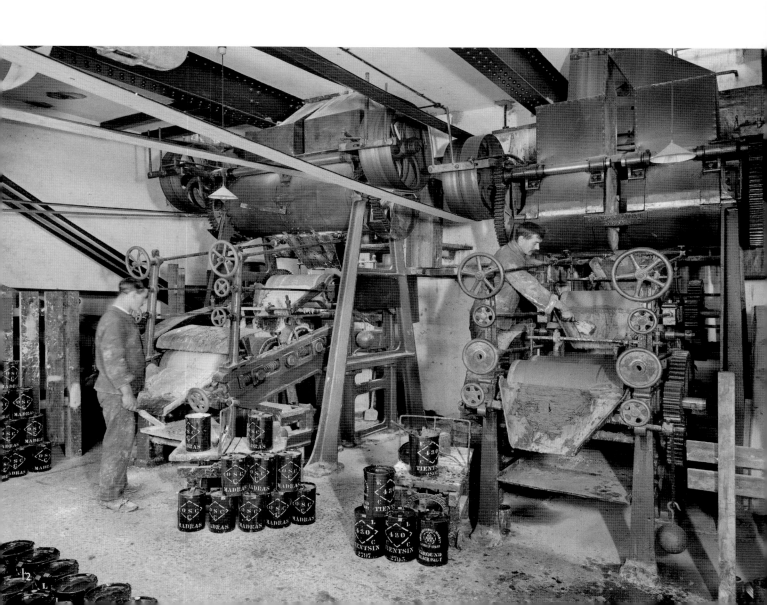

Male and female workers at
Frank Cooper's Marmalade Factory,
Oxford, Oxfordshire.
Henry Taunt *1902*

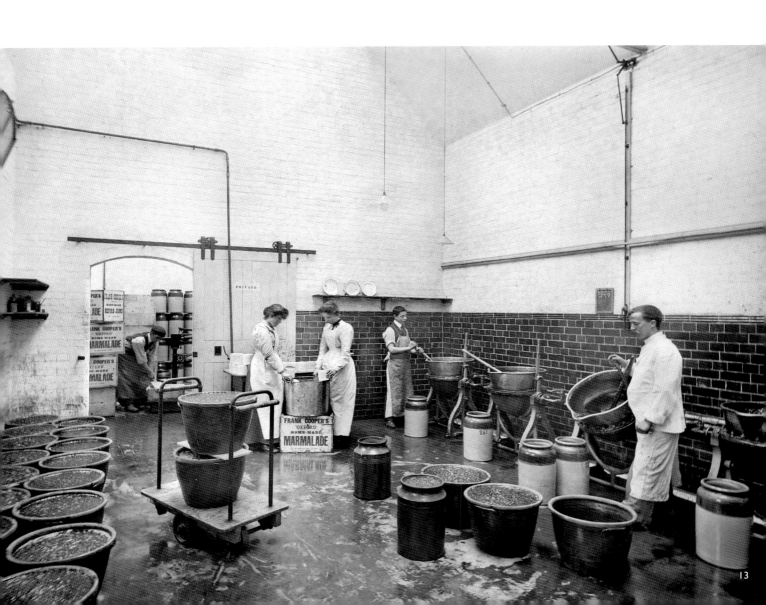

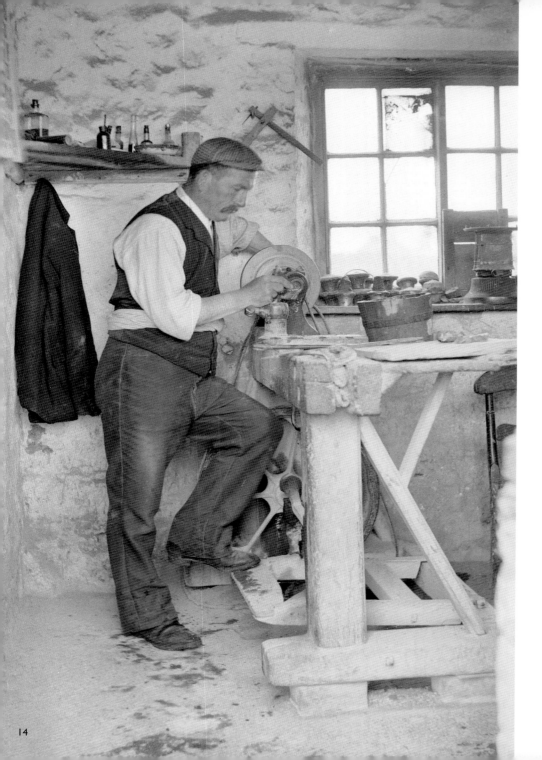

A craftsman working at a bench.
Alfred Newton and Son
1896-1920

Sponging the surface of a cup.
The handles will be added at a
later stage. Stoke-on-Trent,
Staffordshire.
Eileen 'Dusty' Deste *1960-1974*

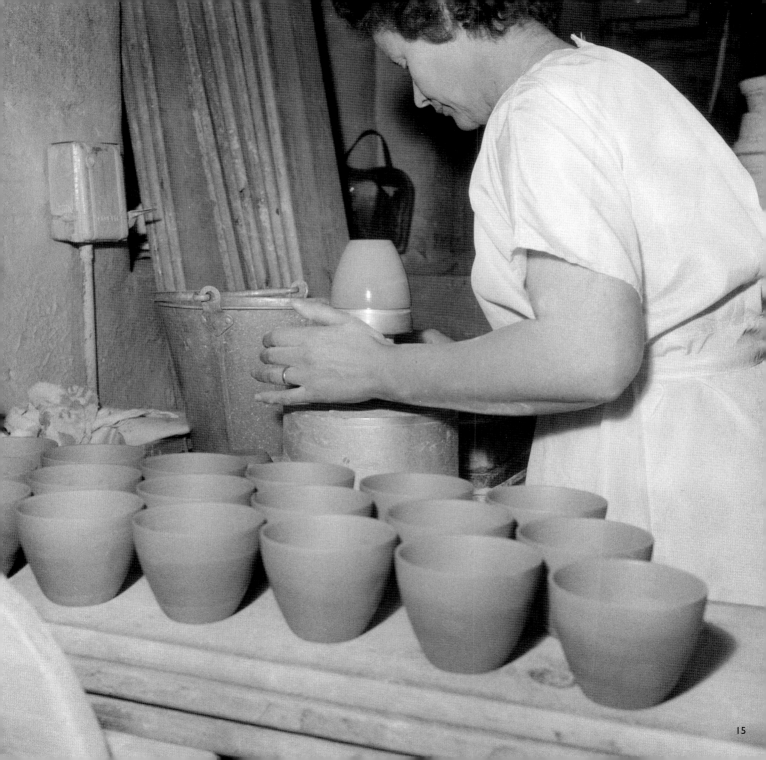

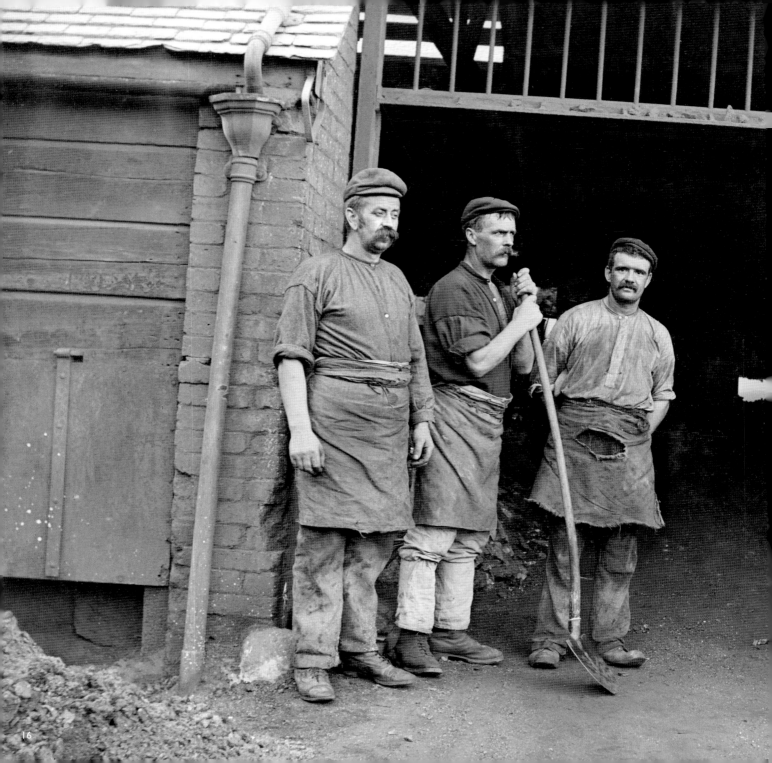

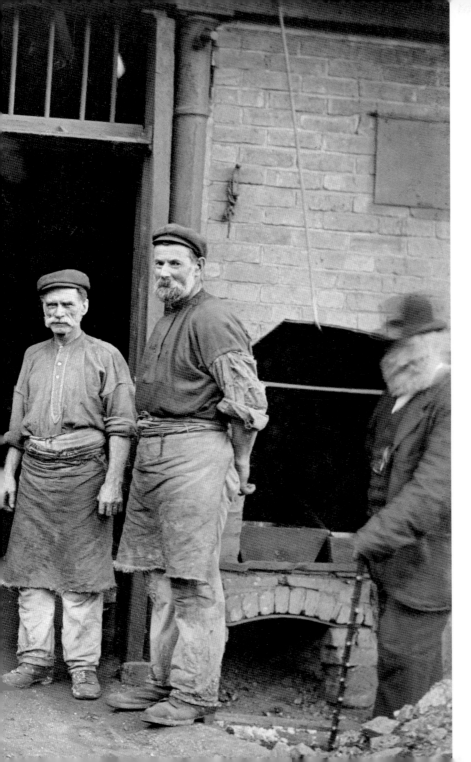

Workmen at the entrance to
Chyandour Smelting Works,
Penzance, Cornwall.
Photographer unknown *c1907*

Mr Jeffries, blacksmith, in his forge
at Southrop, Gloucestershire.
S. Pitcher *1938*

Bays of raw cotton or wool
awaiting processing in a mill.
East Lancashire or West Yorkshire.
Eileen 'Dusty' Deste *1960-1974*

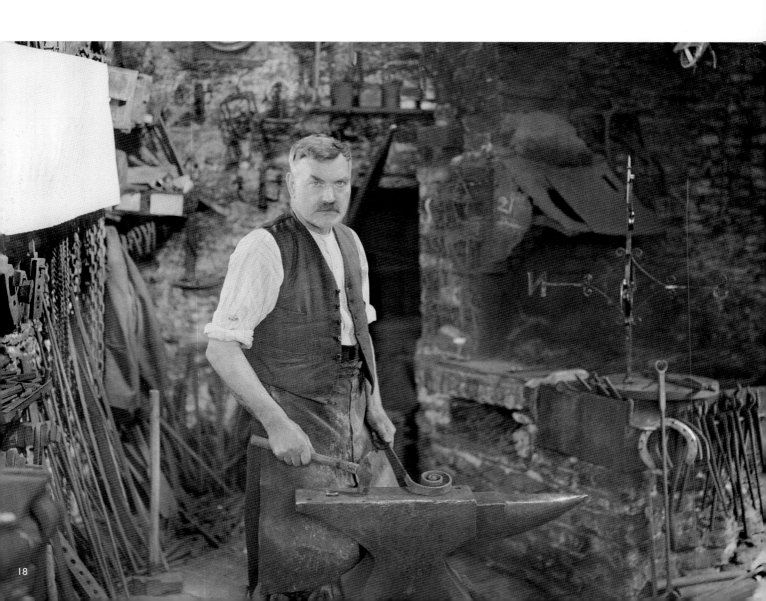

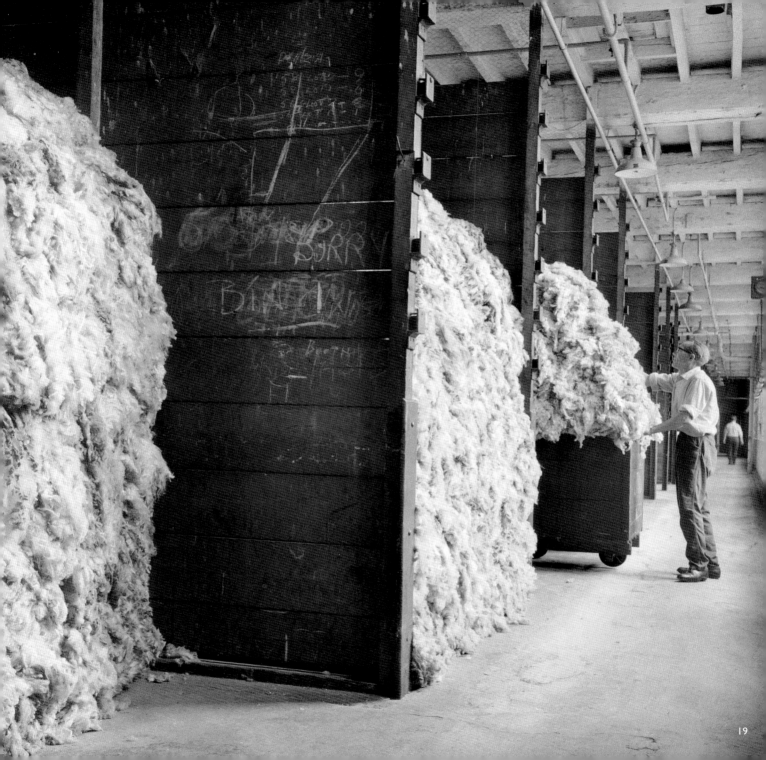

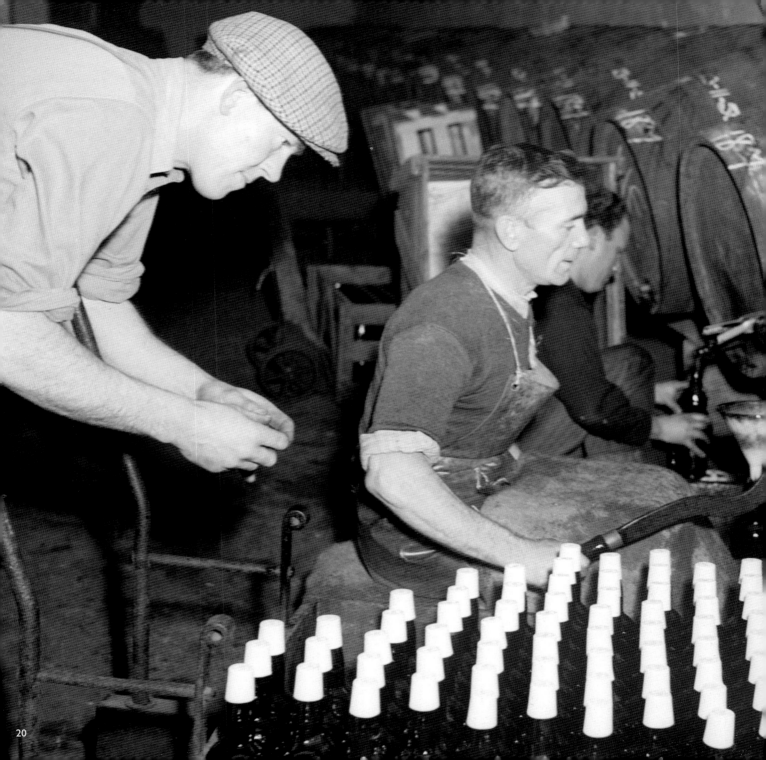

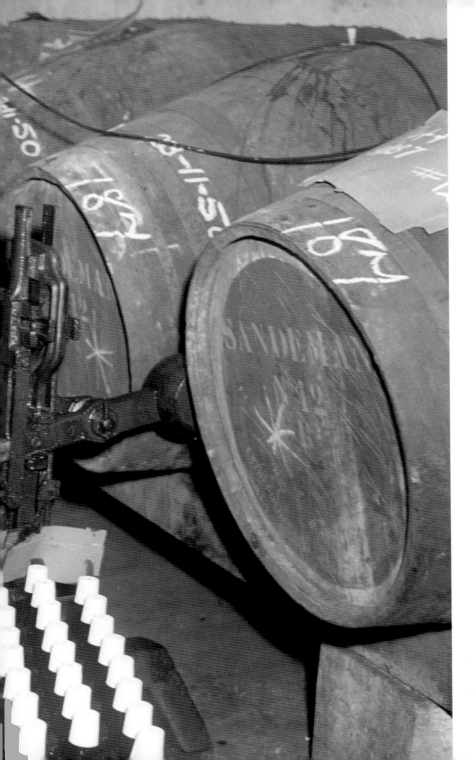

Bottling *Sandeman* port at
Cutler Street Warehouse, London.
S W Rawlings *1945-1965*

Setting the kiln with saggars
of pottery to be fired.
Eileen 'Dusty' Deste *1960-1974*

Finishing off cloth and loading
it onto a truck.
Eileen 'Dusty' Deste *1960-1974*

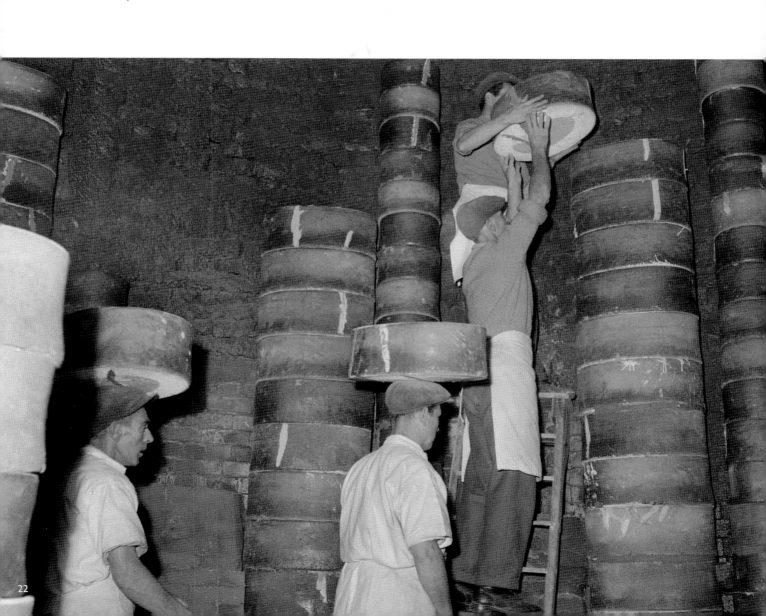

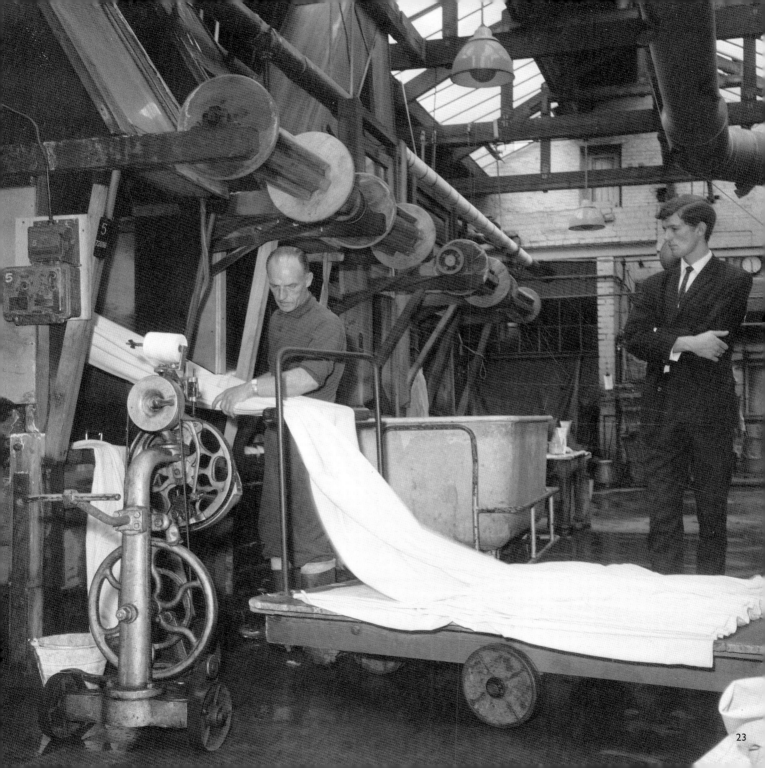

23

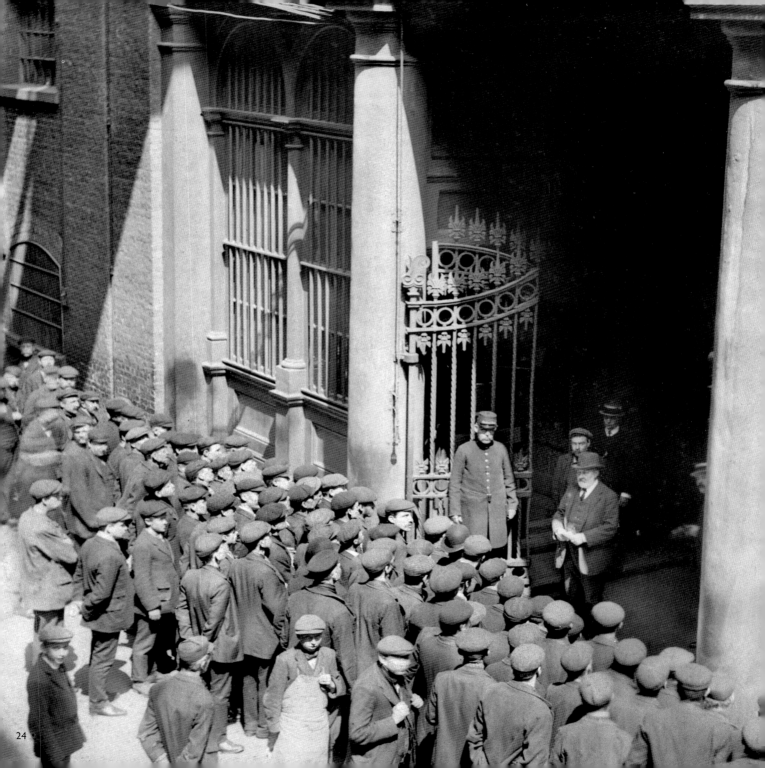

Men queuing for casual work
at London docks.
c1910

Pay day at Butlers Wharf, London.
c1910

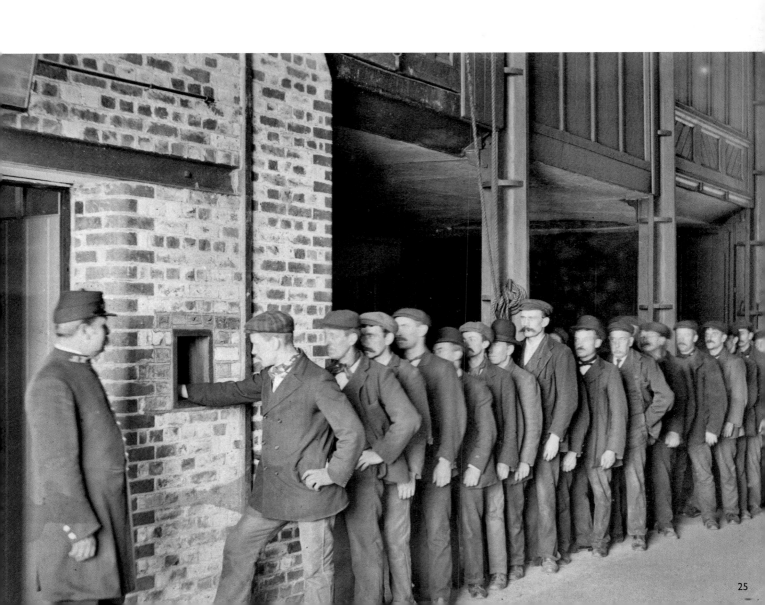

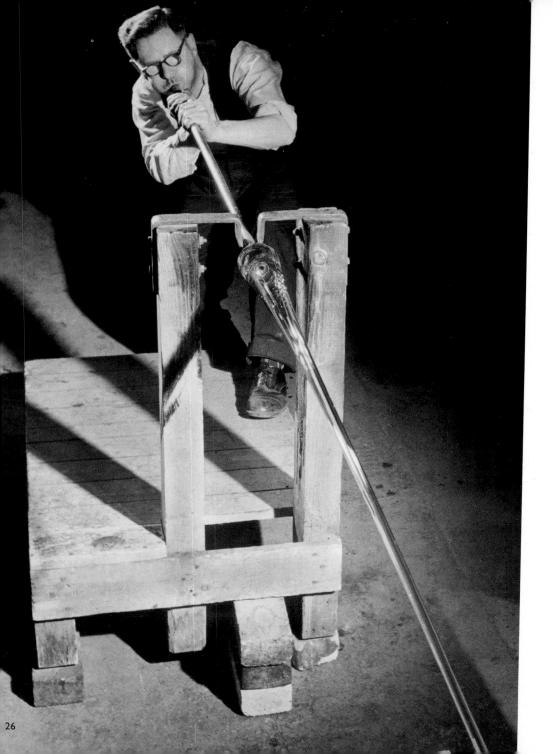

Glassblowing at
Osram Glass Works,
Newcastle upon Tyne.
Photographer unknown
c1950

The Teofani cigarette
factory in Brixton, London.
Bedford Lemere
1916

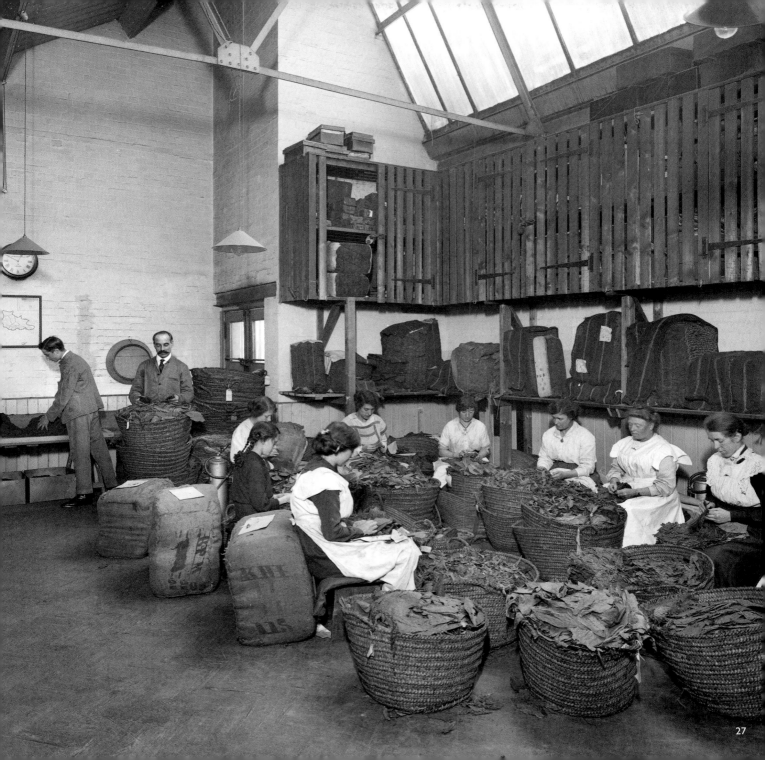

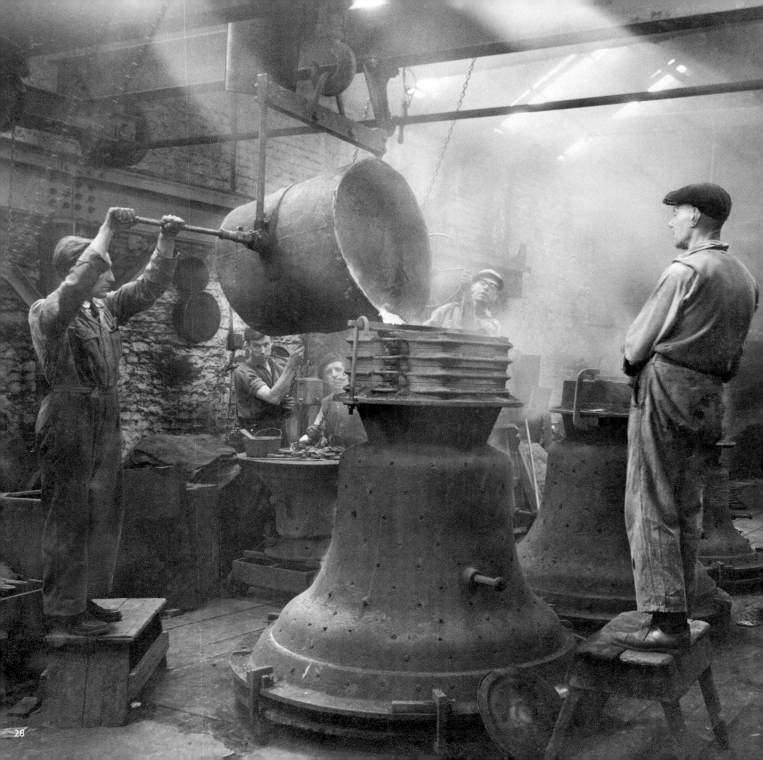

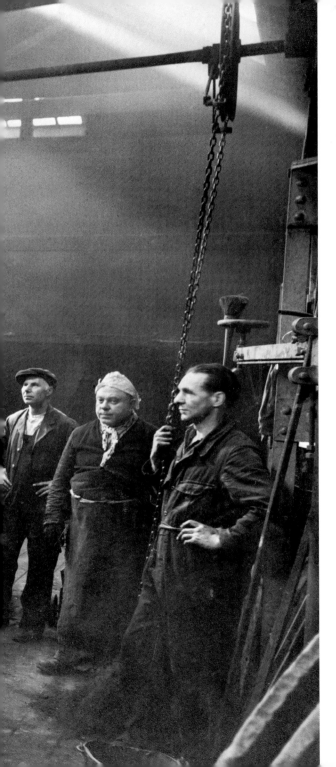

Casting at the Church Bell Foundry
on Whitechapel Road, London.
Campbell's Press Studio *1956*

Mrs Walsh's Factory at 26 Thorpe Street,
Macclesfield, Cheshire.
J M Prest *1956*

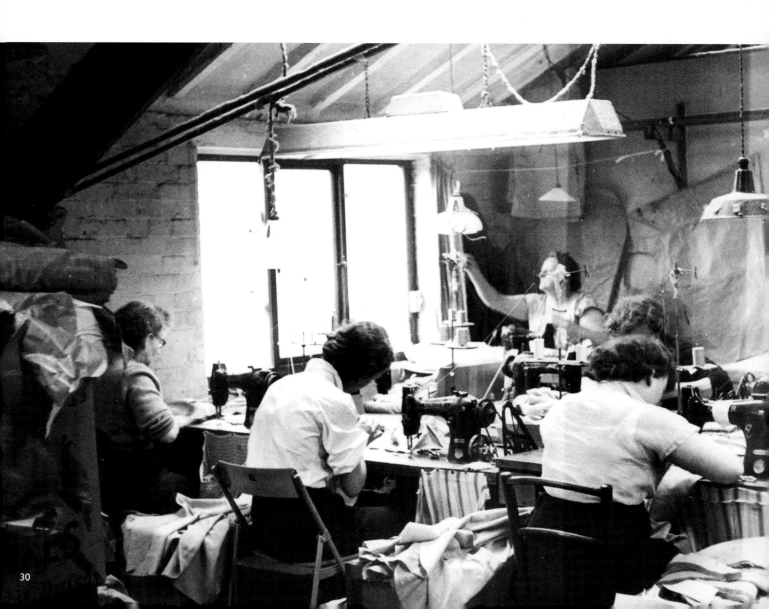

Preparing leather for the shoe and
boot industry at Dickens Brothers
Leather Works in Northampton.
Photographer unknown *c1929*

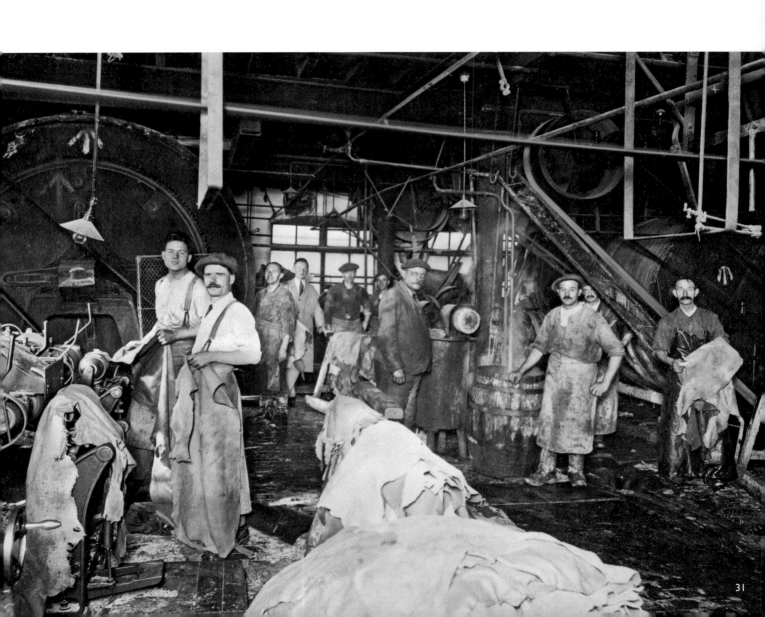

MAINTENANCE MINING & CONSTRUCTION

"I STARTED work down the pit at the age of 14 earning 13/6 a week. I worked on the screens until I was 15 when I went underground. You had no choice about what job you did, you just went where you were told. I used to walk an hour to work, then another half hour underground to get to the coal face. I had to get in the tin bath when I got home or I fell asleep in my pit muck while I was eating my dinner. It was a big day when they nationalised the coal industry because we got pit baths."

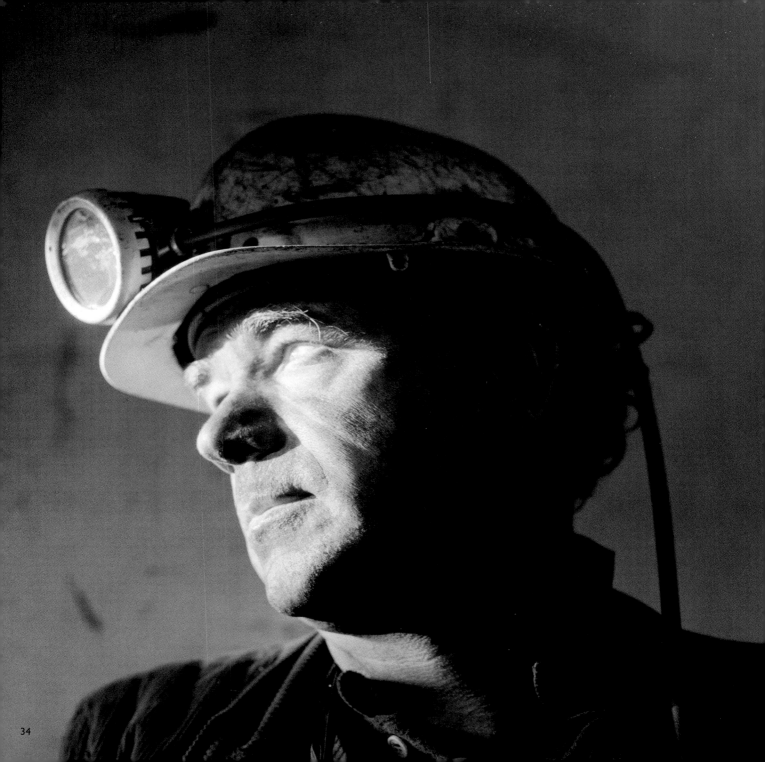

A miner at Hay Royds Colliery
in Denby Dale, West Yorkshire.
J O Davies *January 1993*

Two miners in the lamp room at
Frickley Colliery, South Elmsall,
West Yorkshire.
J O Davies

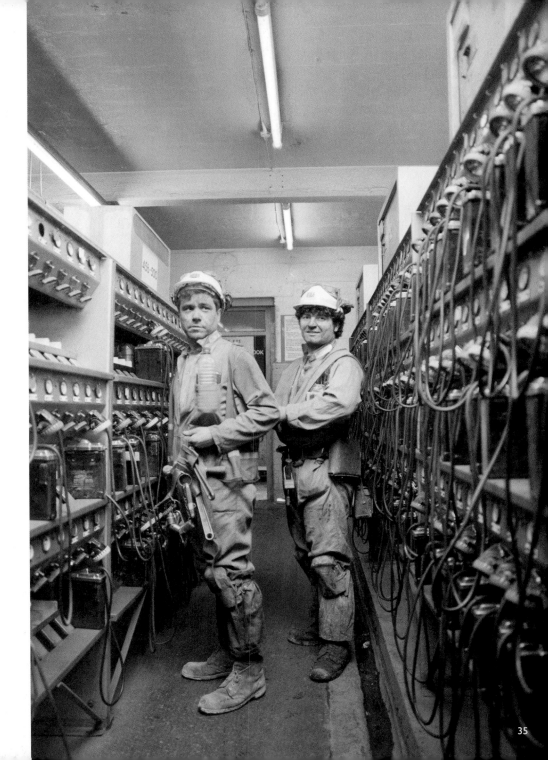

35

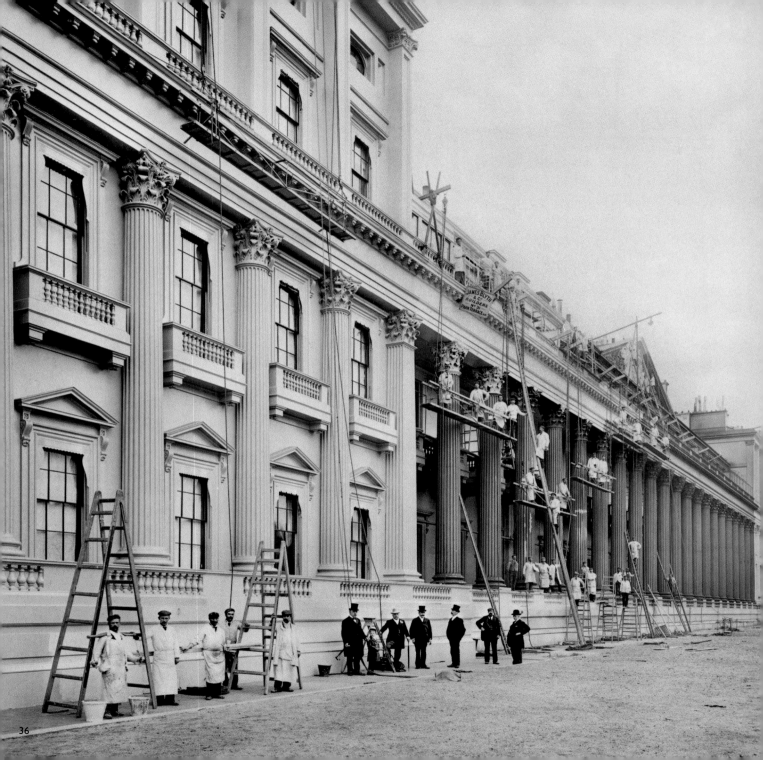

Decorating the façade of
Carlton House Terrace,
Westminster, London.
Bedford Lemere *1898*

Maintaining the clock face
of Big Ben, Westminster.
Campbell's Press Studio

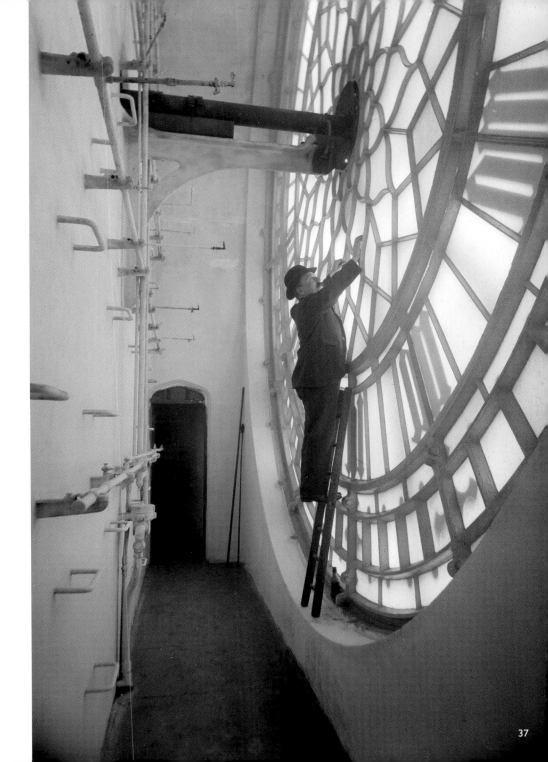

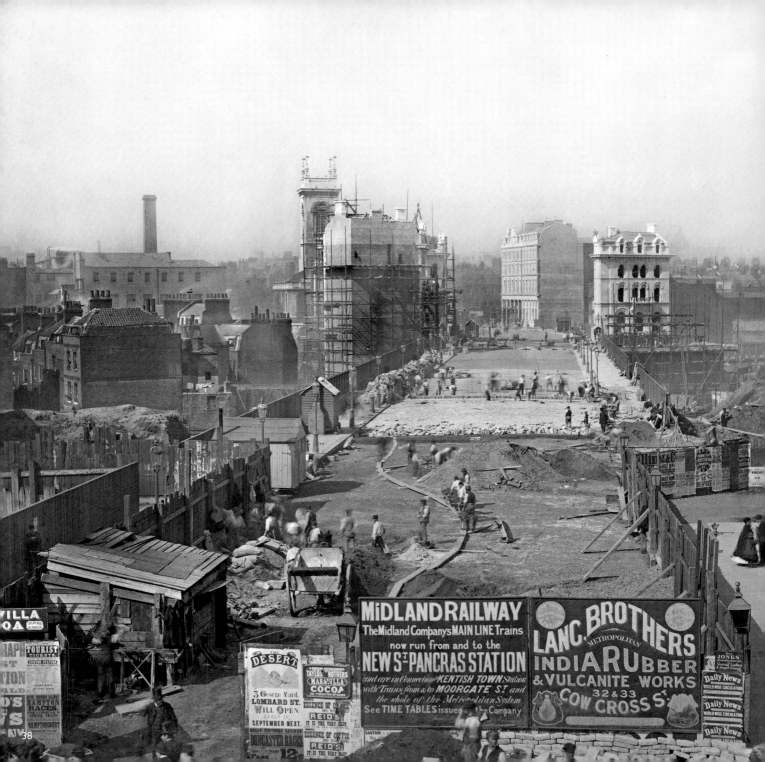

Construction of the
Holborn Viaduct, London.
Henry Dixon *September 1869*

An industrial chimney
in Hackney, East London,
being cleaned by steeplejacks.
Laurence Goldman *November 1965*

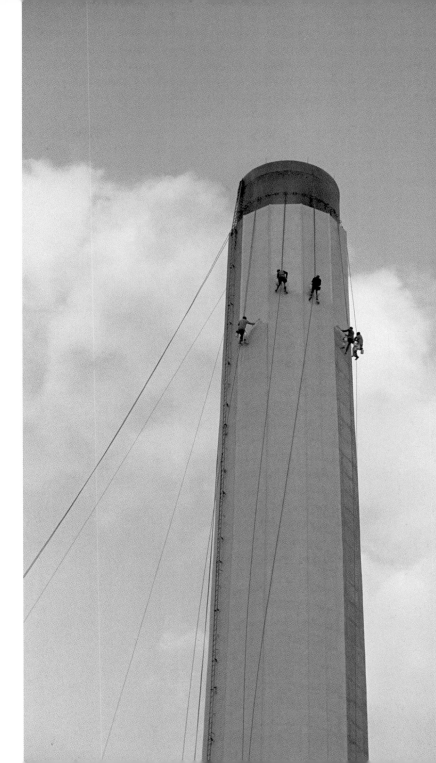

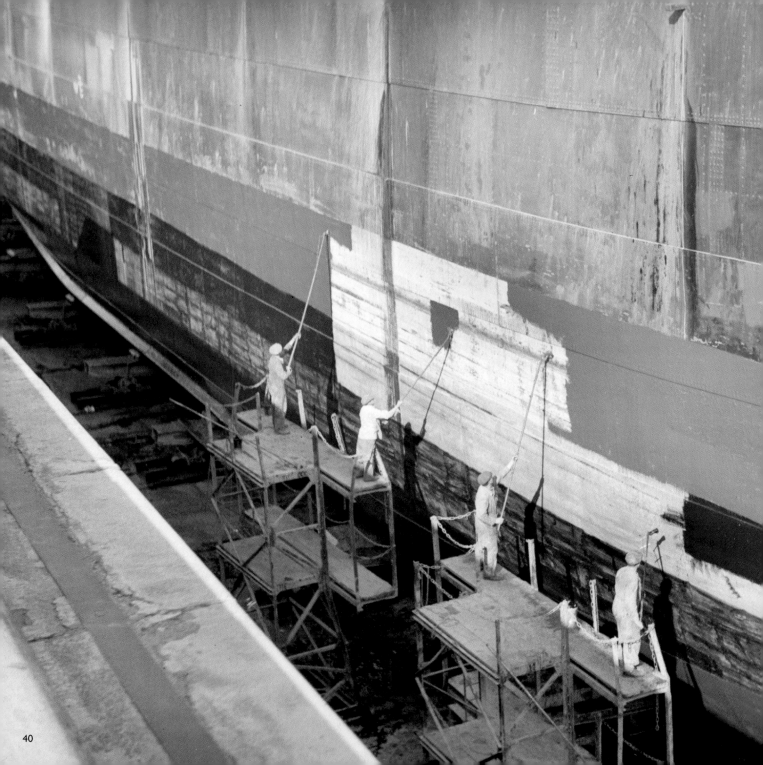

Painting the hull of a ship
in dry dock, Tilbury, Essex.
S W Rawlings *1945-1965*

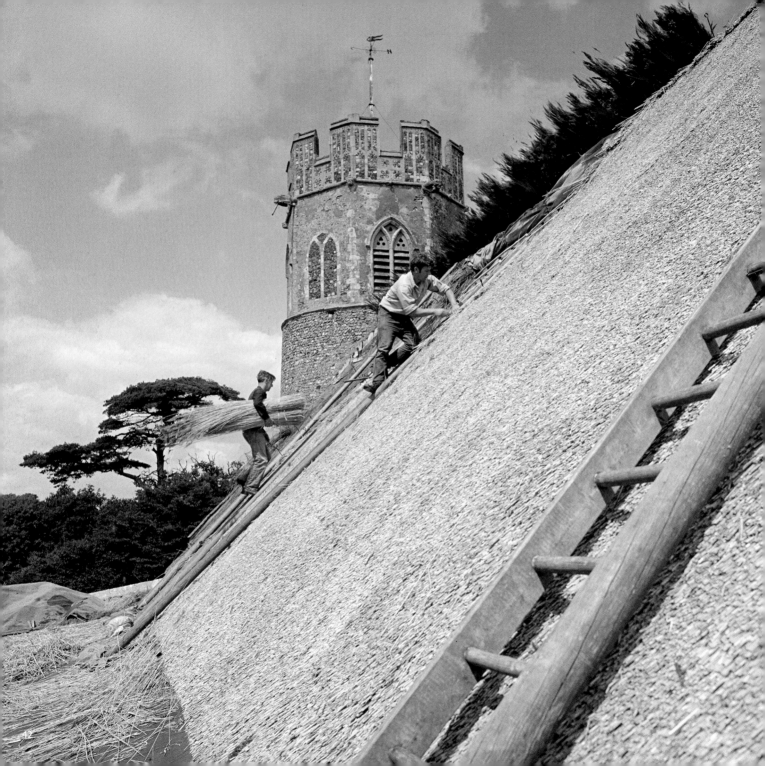

Re-thatching the roof of St Peter's Church, Theberton, Suffolk.
John Gay *1956*

A chair mender working on the pavement in Hampstead, London.
Laurence Goldman *October 1961*

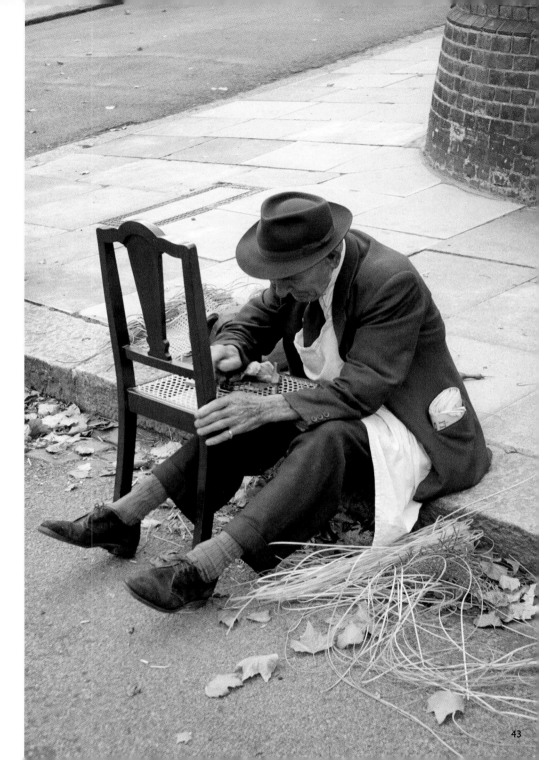

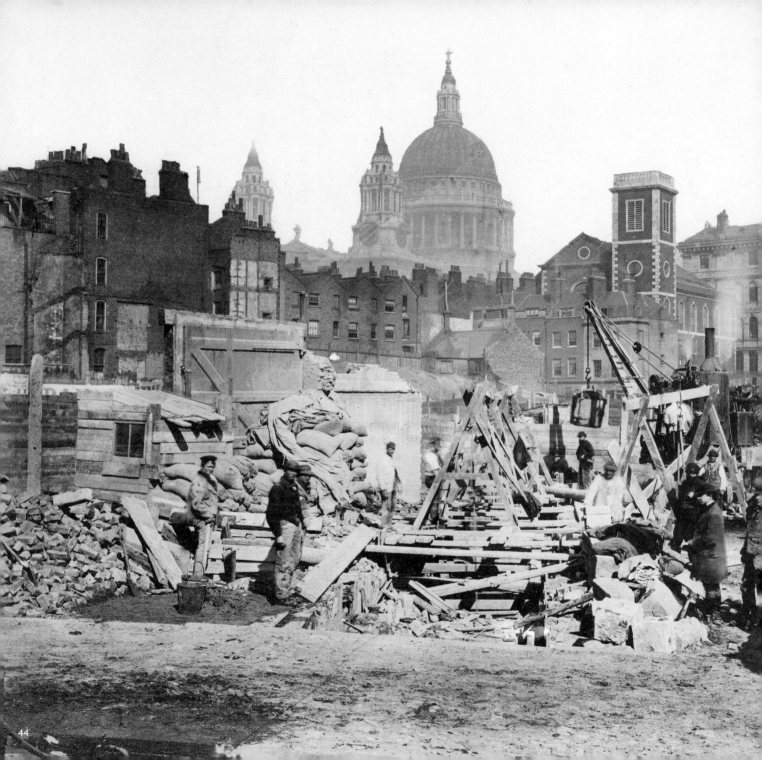

Queen Victoria Street, City of London.
Photographer unknown *1867-1871*

Quarrymen posed at the entrance
to Westington Quarry, Chipping
Campden, Gloucestershire.
Henry Taunt *1895*

A mason, Joe Moorley, at work
in Gregory's Quarry, Mansfield,
Nottinghamshire.
Hallam Ashley *January 1954*

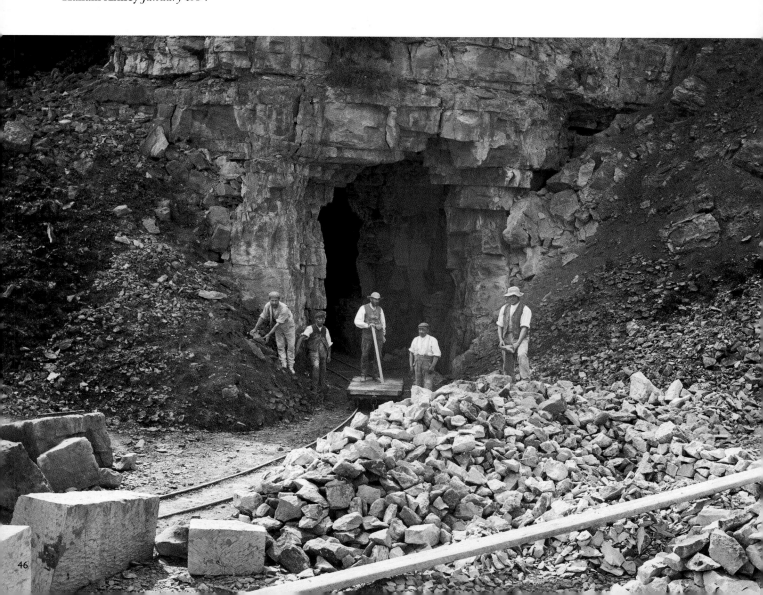

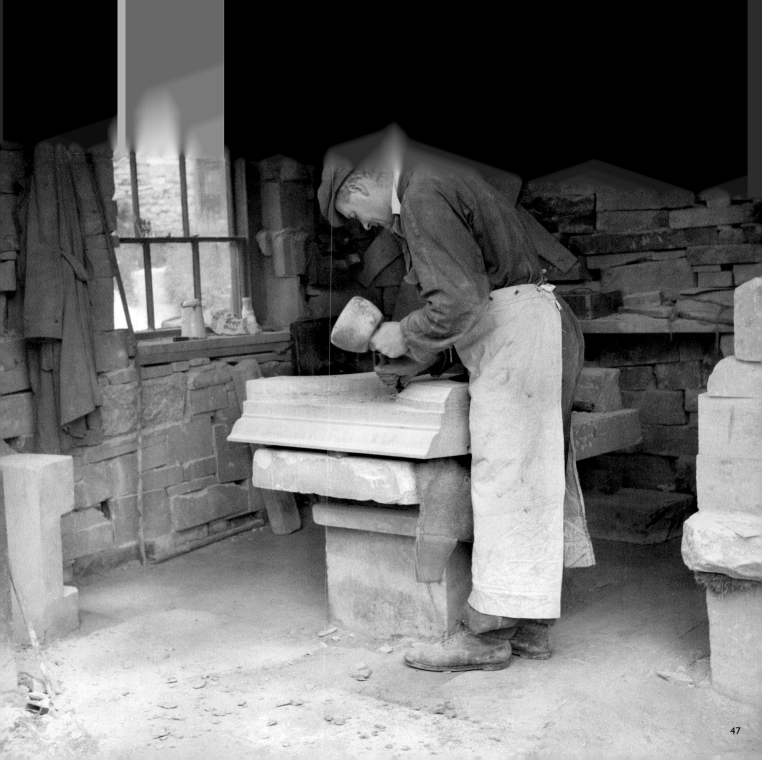

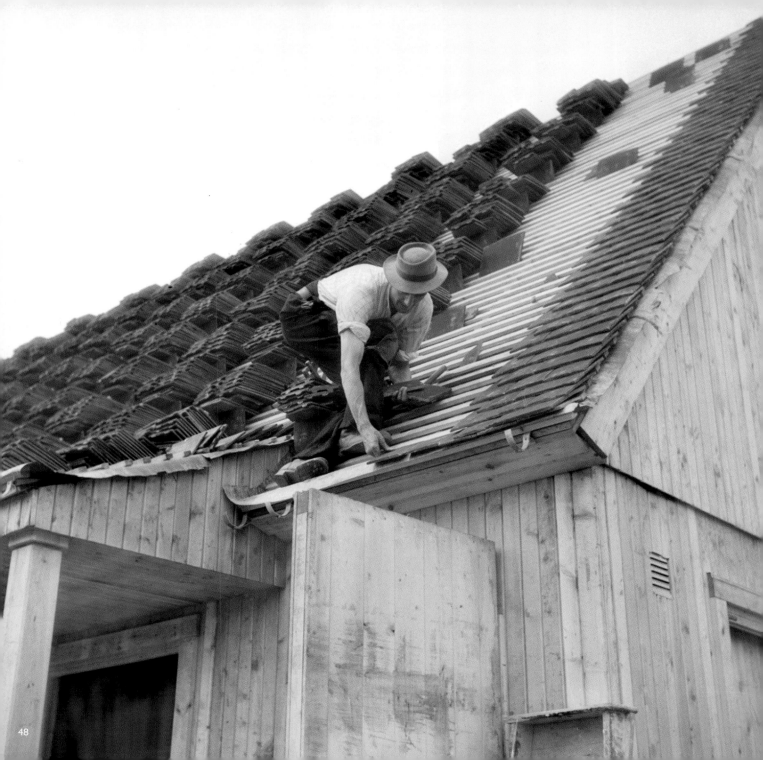

A roofer tiling a wooden house
at Great Ellingham, Norfolk.
Hallam Ashley *1946*

Construction of a Prefab in
Northolt, London, used to
relieve the housing shortage
in post war Britain.
Ministry of Works *July 1947*

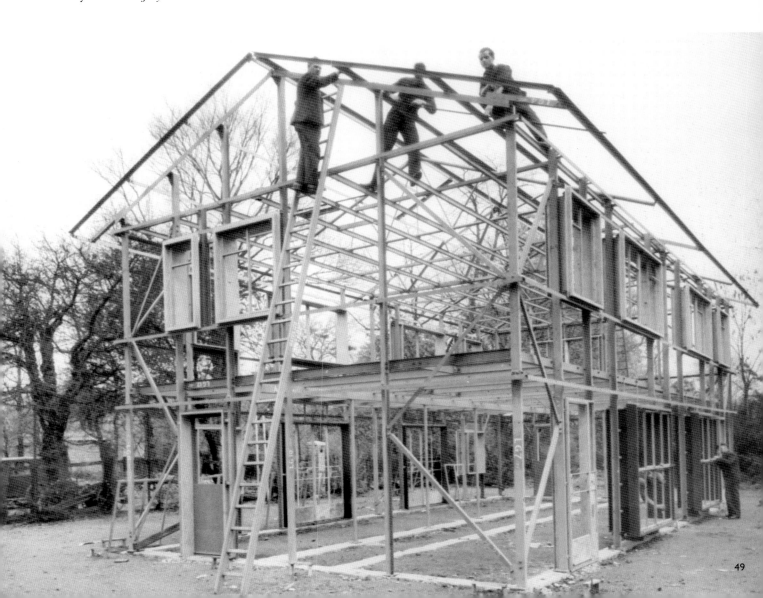

The *Cretemanor* concrete barge under construction at Hughes and Stirling's shipyard, Preston, Lancashire.
Arthur Winter *1918*

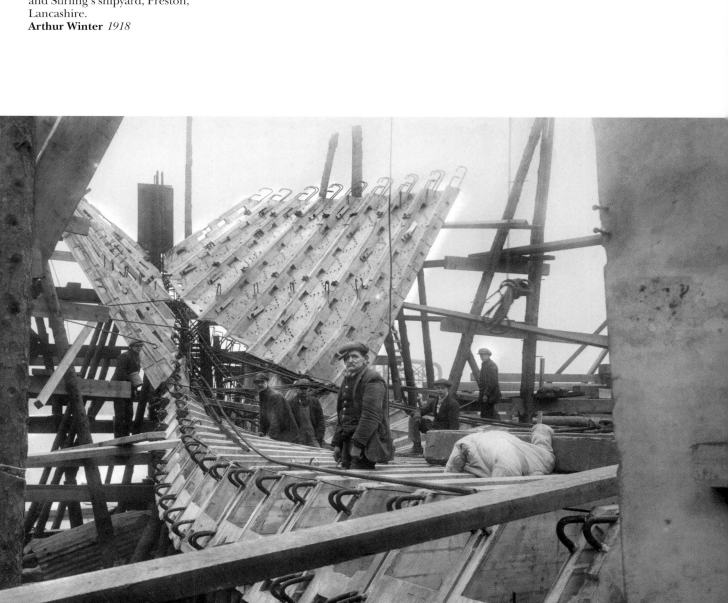

Contractors meeting on a building
site at Waterloo, London.
Laurence Goldman *October 1963*

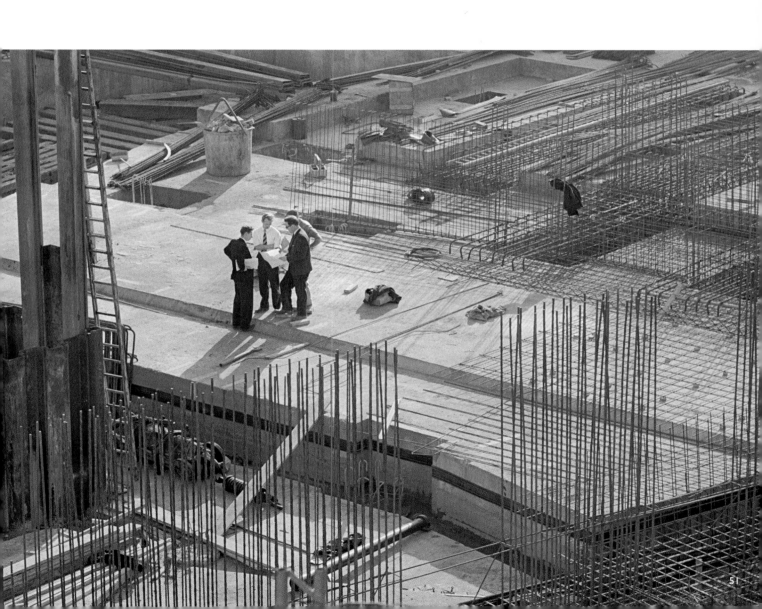

A team of navvies surfacing
a residential street.
Bedford Lemere
May 1920

Pouring concrete during
construction of the Tate and Lyle
Sugar Silo at Huskisson Dock,
Liverpool, Merseyside.
Photographer unknown *June 1956*

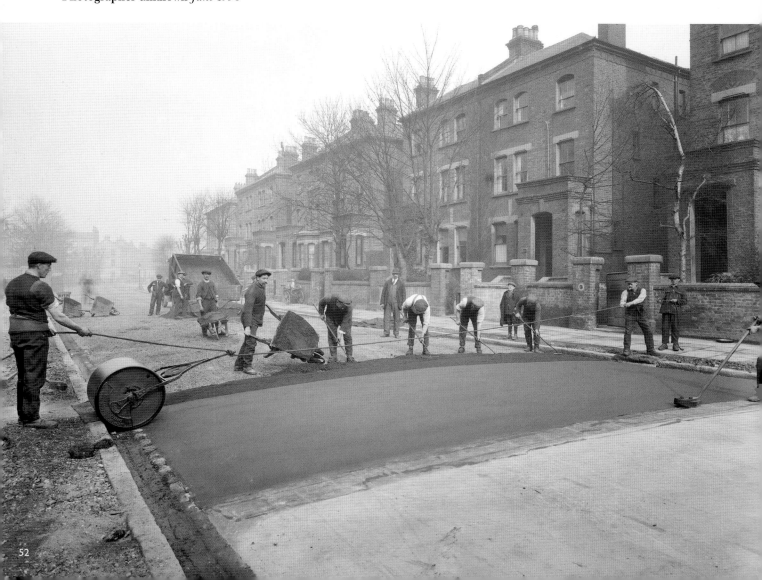

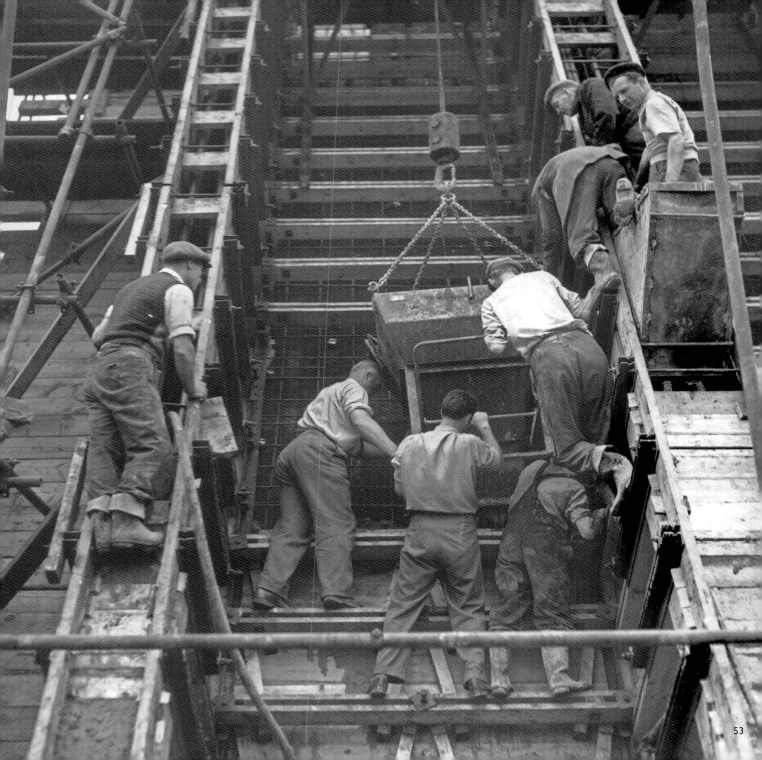

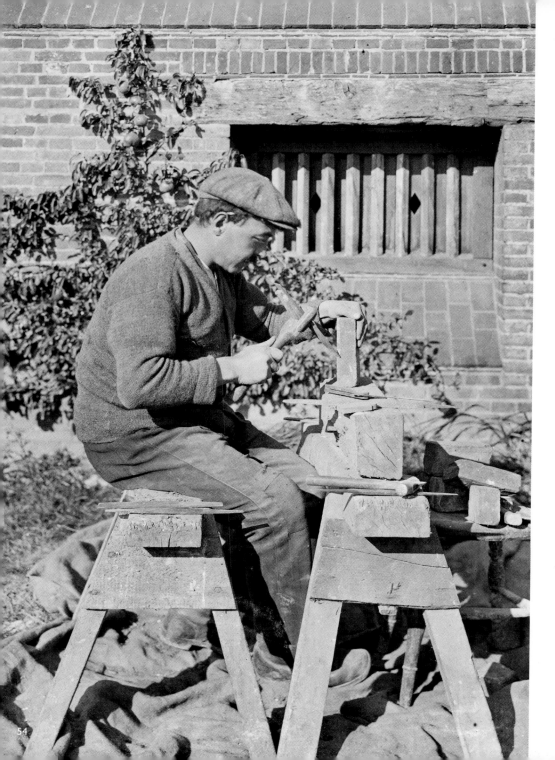

Shaping bricks at Great Dixte
Northiam, East Sussex.
Nathaniel Lloyd *October 1919*

The construction of St Bride's
Street, City of London.
Henry Dixon *1871*

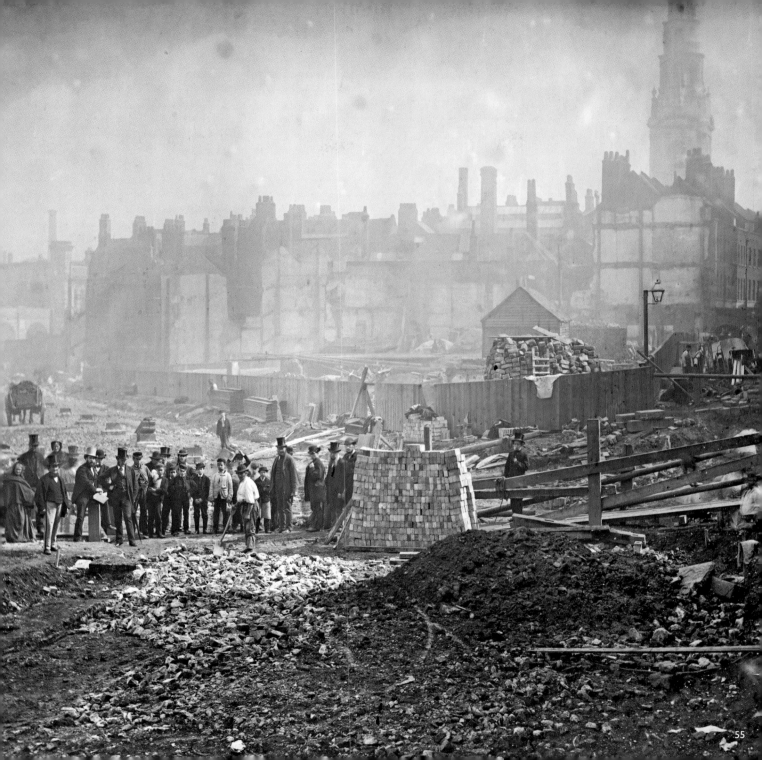

AGRICULTURE
& FISHING

"*I* WAS *born on a farm. Before the war it was all horses, no tractors. We made our own lard and butter. Always had bacon and ham. 'Beastings' was a deep yellow creamy stuff you got from cows only after they'd calved. You could make a lovely custard pie. When we killed a pig we used everything. Only thing that were wasted were the squeal. You were only allowed to kill for your own consumption. I never got upset, you can't get sentimental about it.*"

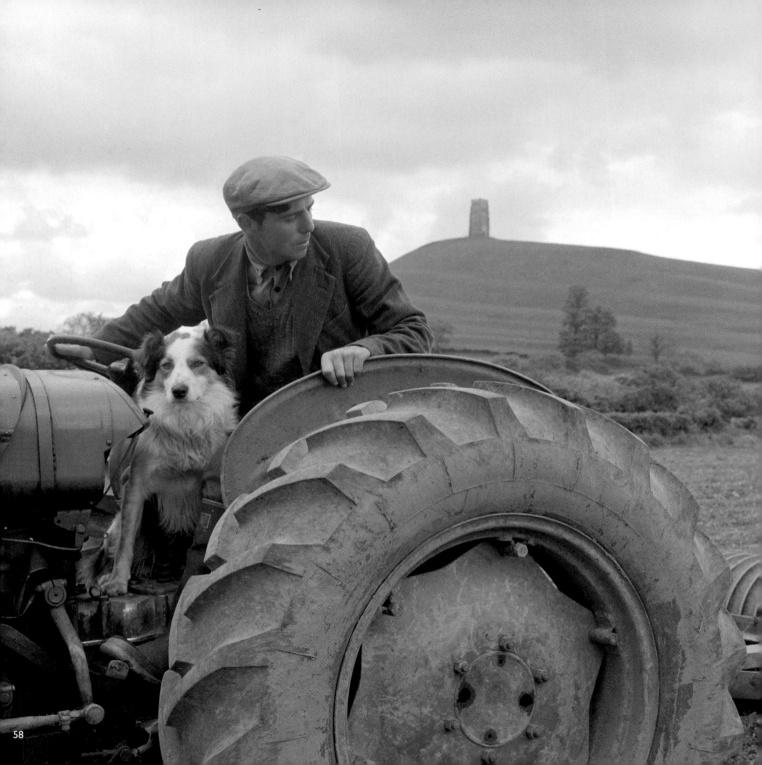

Farmer Marcus Govier and sheep dog on
a tractor near Glastonbury Tor, Somerset.
John Gay *1958*

A plough team at Marple, Greater Manchester.
Alfred Newton and Son *1903*

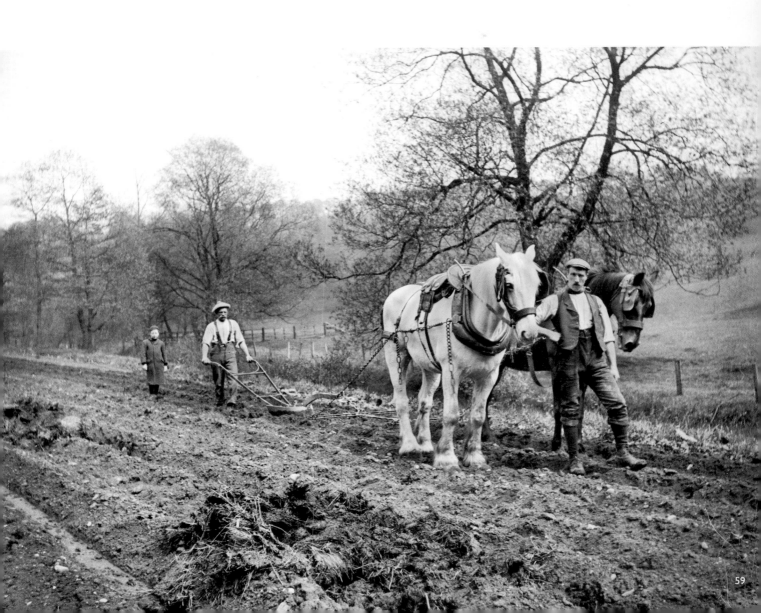

Harvesting crops using a scythe
near Hellidon, Northamptonshire.
Alfred Newton and Son *1901*

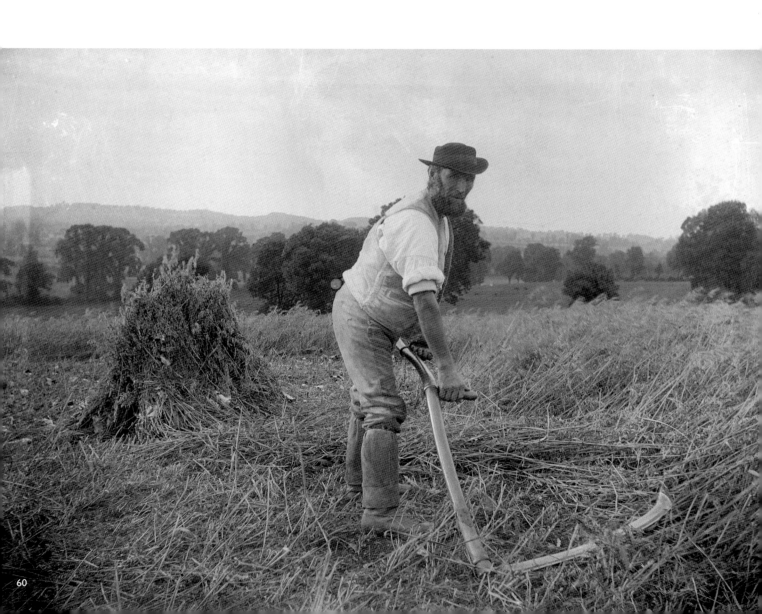

Harvesting with a mechanical harvester
near Hellidon, Northamptonshire.
Alfred Newton and Son *July 1902*

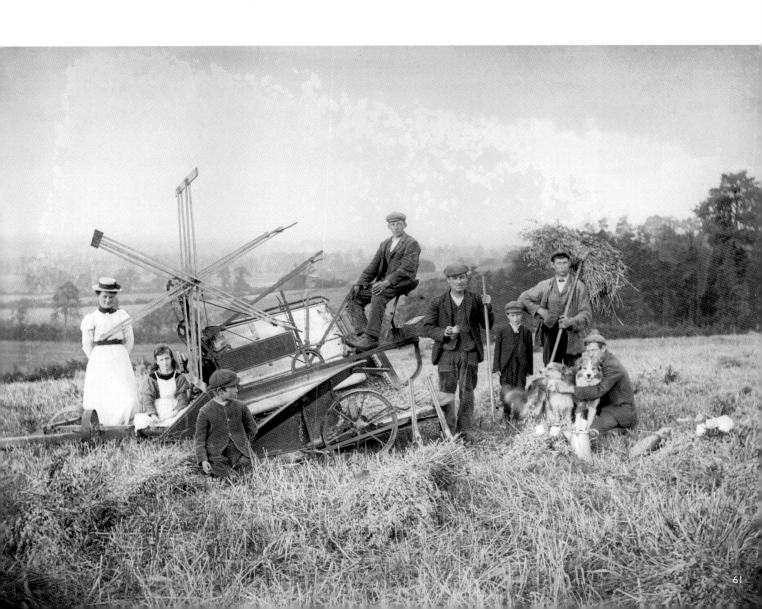

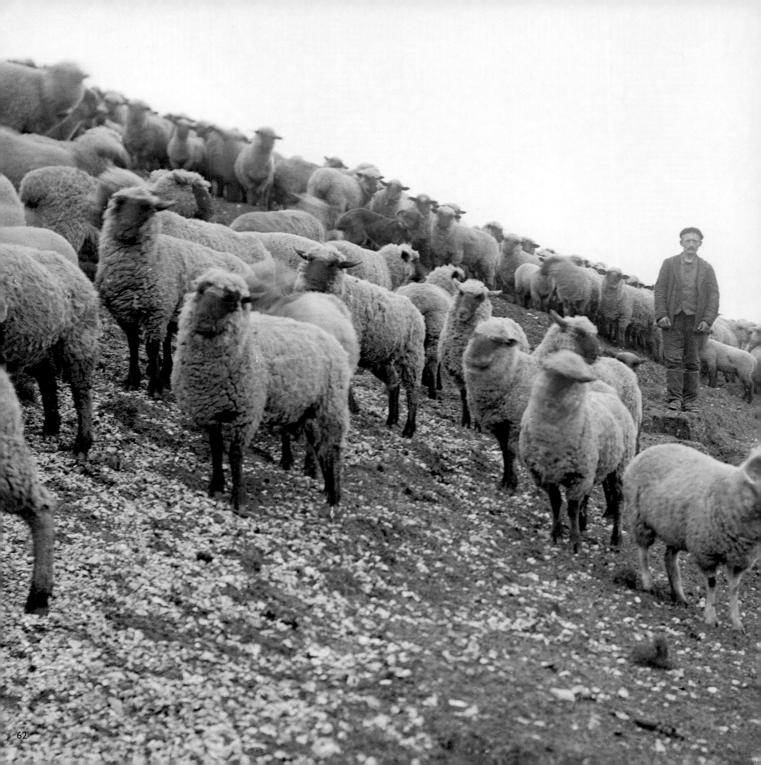

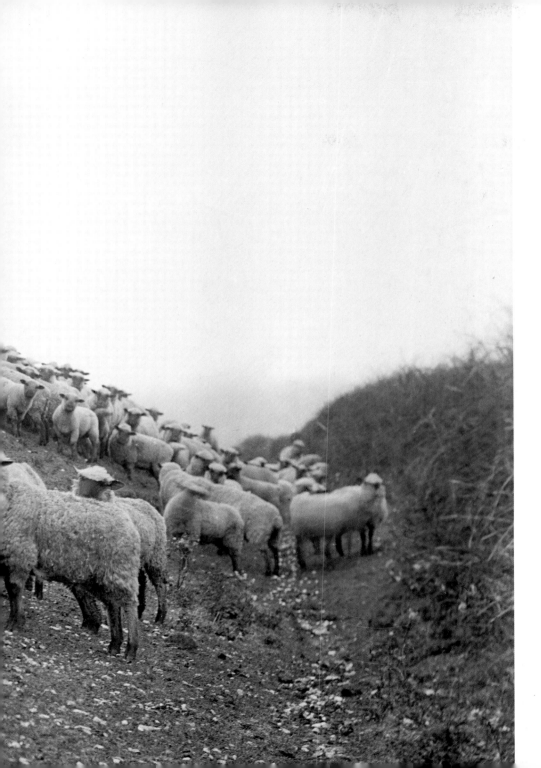

A shepherd with his flock
at West Lulworth, Dorset.
Alfred Newton and Son *1909*

Washing a flock of sheep in the
River Thames at Radcot, Oxfordshire.
Henry Taunt *1885*

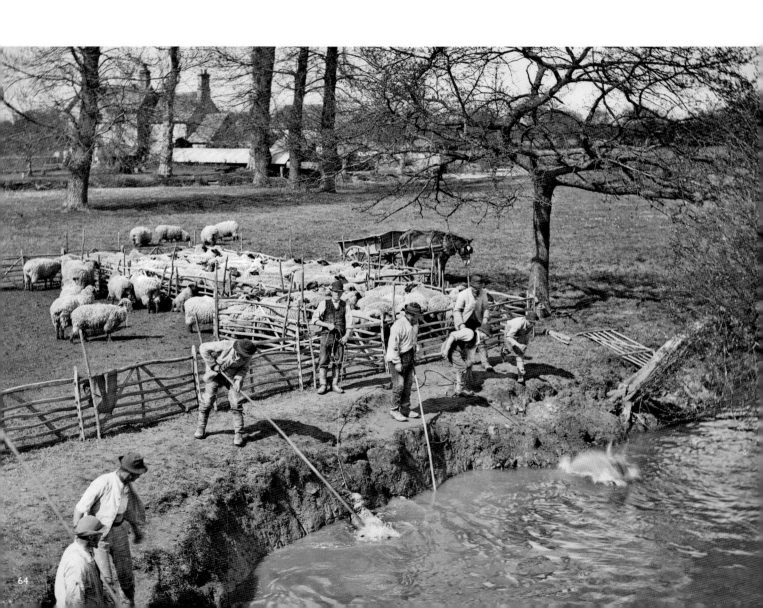

Shearing sheep using traditional
hand clippers.
Alfred Newton and Son *1896-1920*

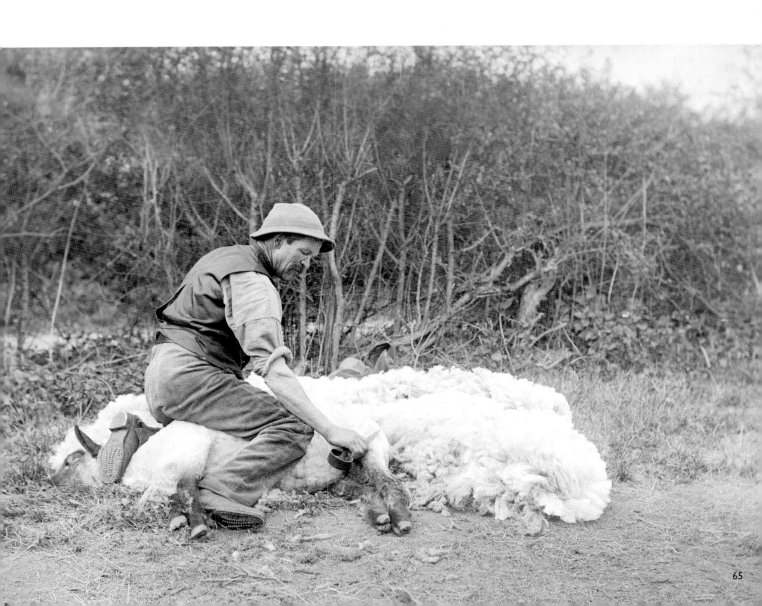

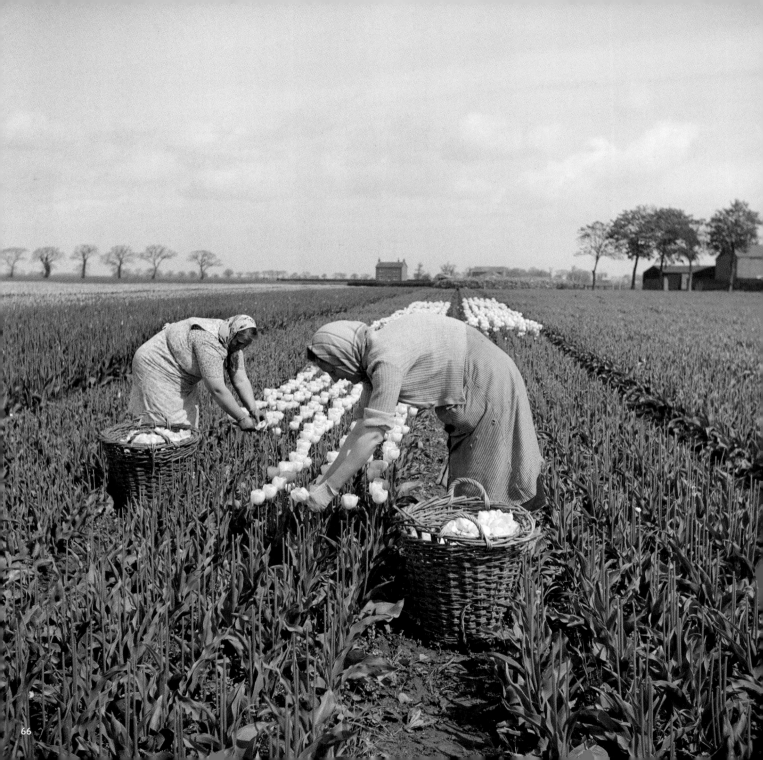

Heading tulips at Fulney, Spalding,
Lincolnshire.
Hallam Ashley *1951*

Beekeeping at Stow Lodge,
Wick Rissington, Gloucestershire.
Alfred Newton and Son *1908*

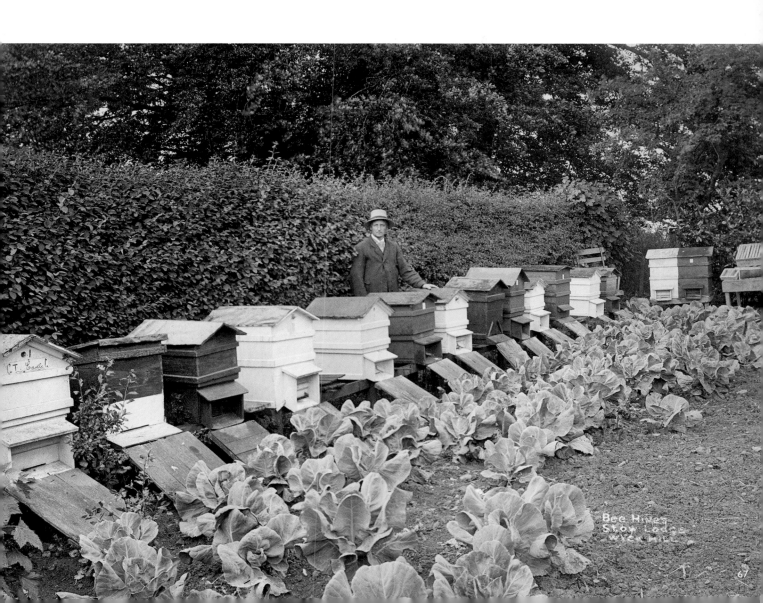

A man and boy demonstrate
their potato planting invention.
Henry Taunt *1900*

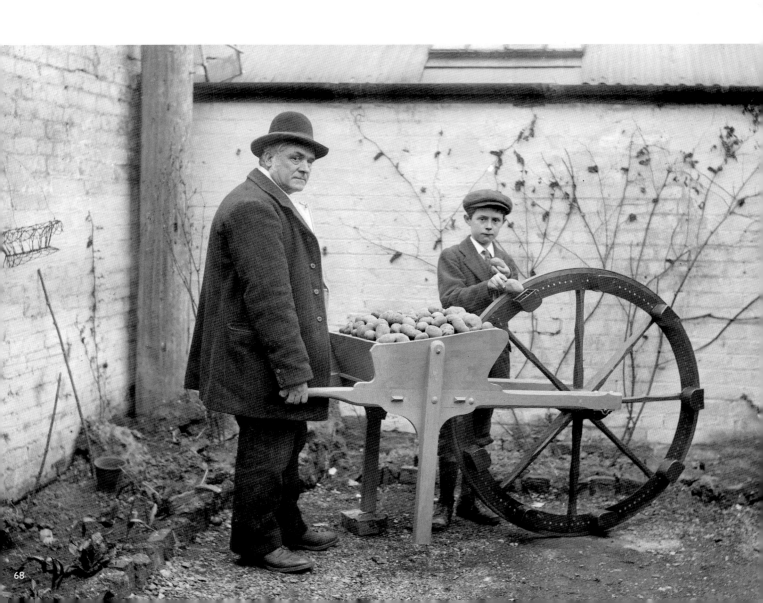

Mr Edward Wyatt and sons,
timber fellers, at Dunstone,
Yealmpton, Devon.
Alfred Newton and Son *1900-1920*

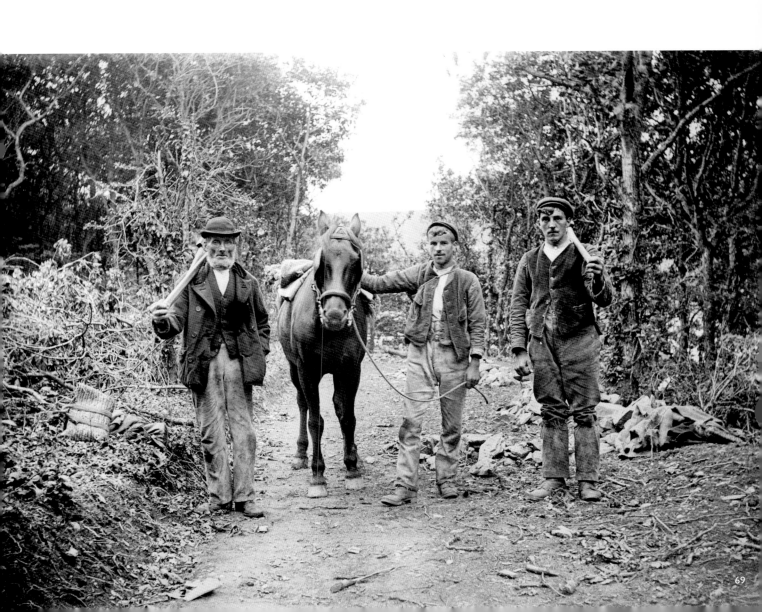

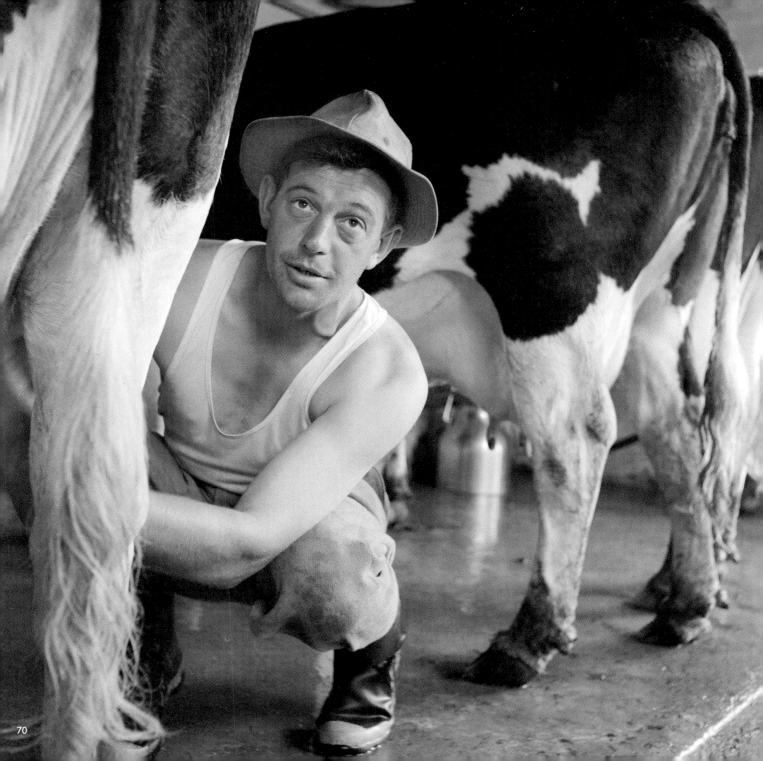

Milking cows at Wood Farm,
Toftwood near East Dereham,
Norfolk.
John Gay *1946-1958*

An agricultural labourer poses
with a sack of hops at Northiam,
East Sussex.
Nathaniel Lloyd *1933*

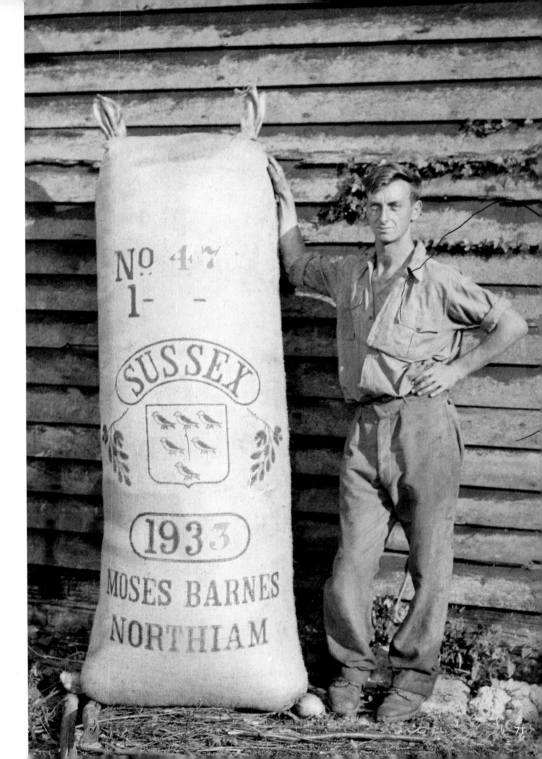

NO 47
1- -

SUSSEX

1933

MOSES BARNES
NORTHIAM

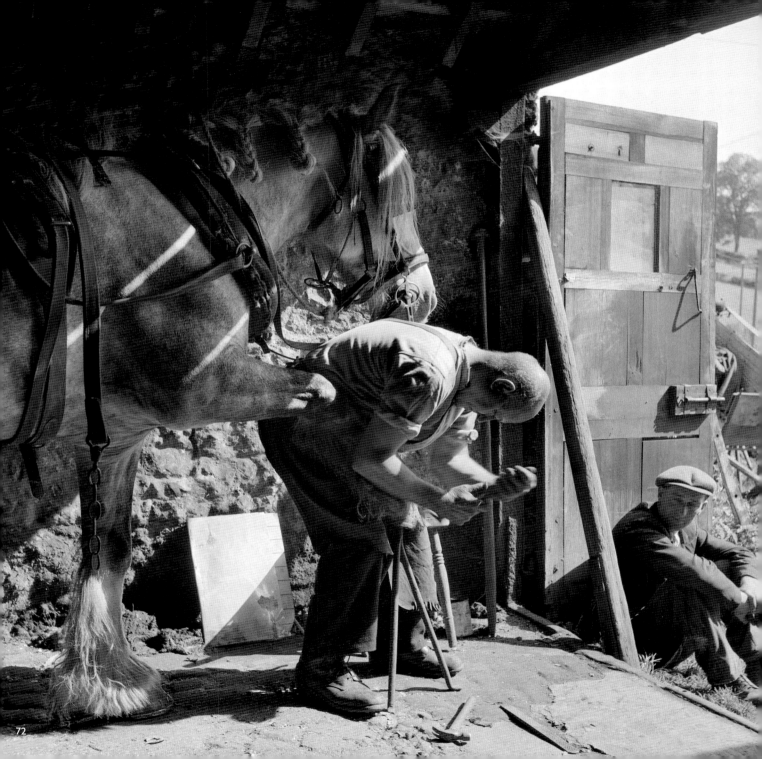

Harry Layzell, farrier, at work
at Branscombe, Devon.
John Gay *1946-1955*

Haymaking near Byfield,
Northamptonshire.
Alfred Newton and Son *1908*

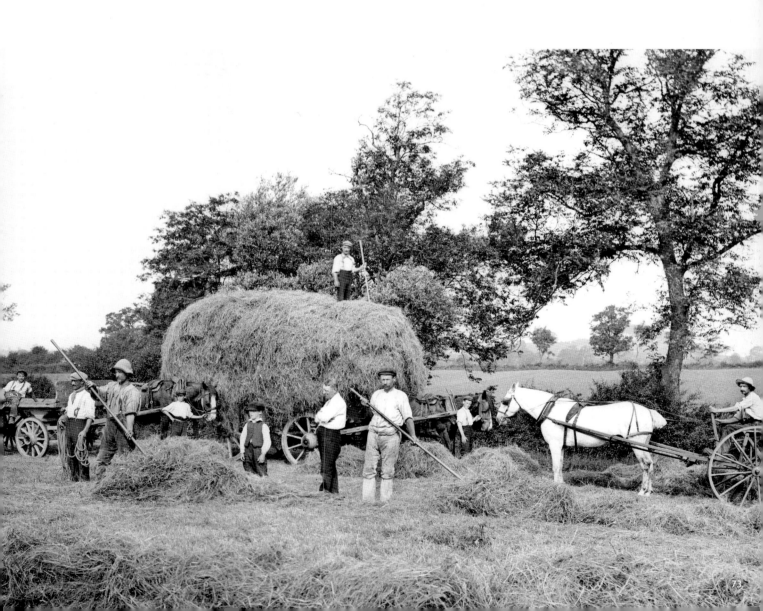

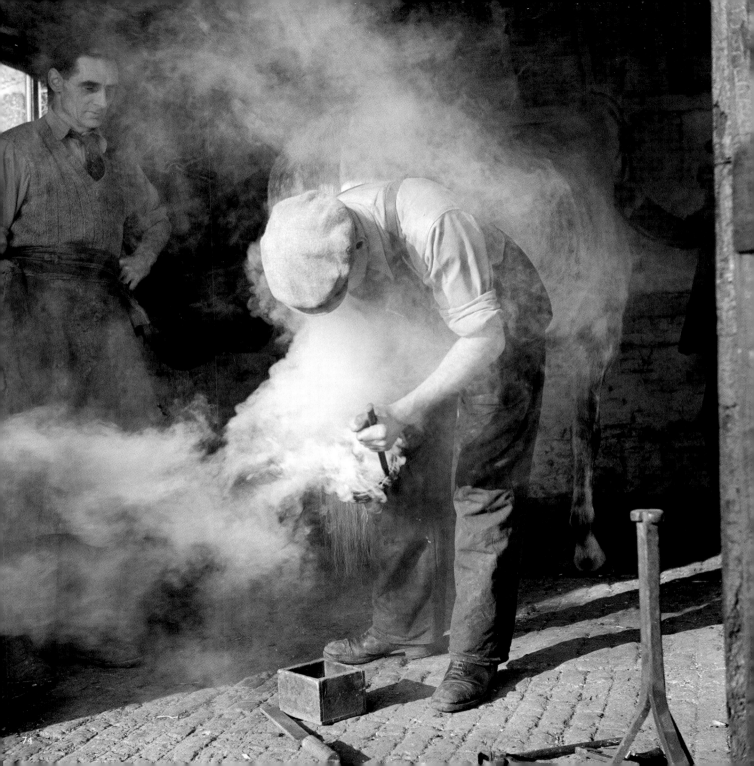

Blacksmith's shop,
Woodbastwick, Norfolk.
Hallam Ashley
February 1949

A portrait of a Grimsby
fisherman on his boat.
Alfred Newton and Son
July 1899

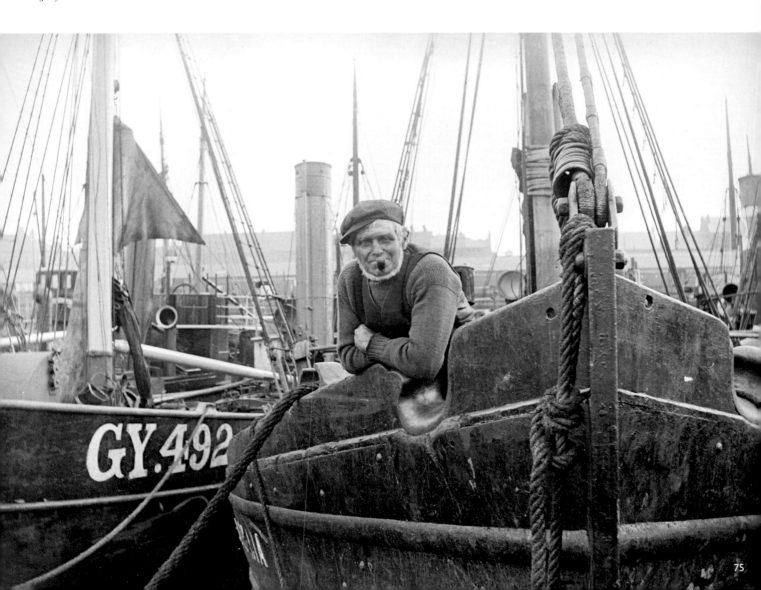

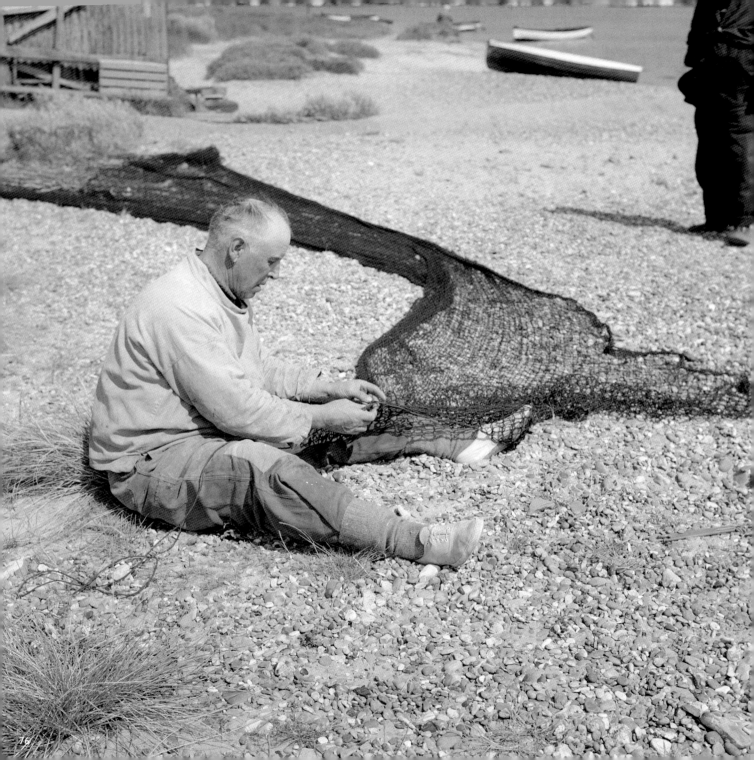

Repairing a fishing net on the
beach at Walberswick, Suffolk.
Laurence Goldman *June 1960*

Fisherwomen gut and pack fish
into barrels.
Alfred Newton and Son
1896-1920

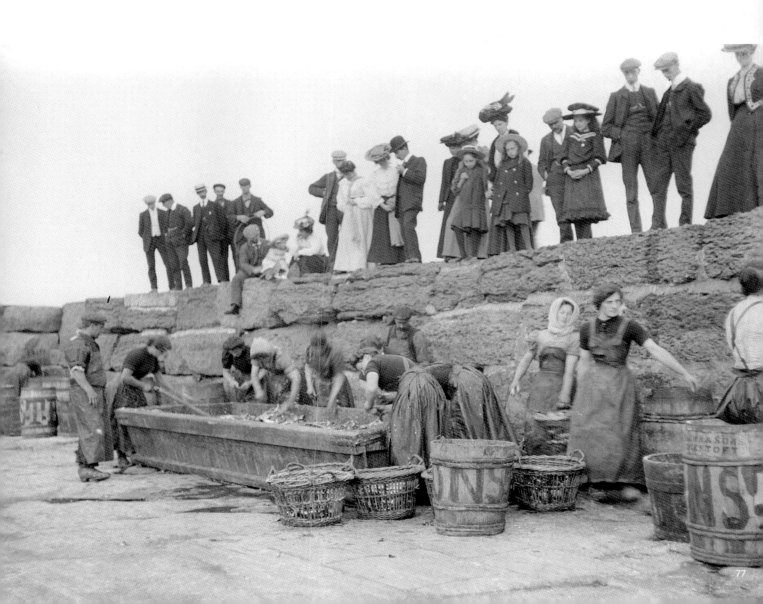

OFFICE

"*I WORKED in an accountants' office. I was amazed at what was going on in town after being brought up in a village. People in my office egged me on to get a car. There weren't many people in the village had a car and I suppose it caused a bit of a comment that a single woman had one.*"

The Mailing Department at the
International Correspondence
School, Kingsway, London.
Bedford Lemere *1909*

Taking dictation in an office at the
International Correspondence
School, Kingsway, London.
Bedford Lemere *1909*

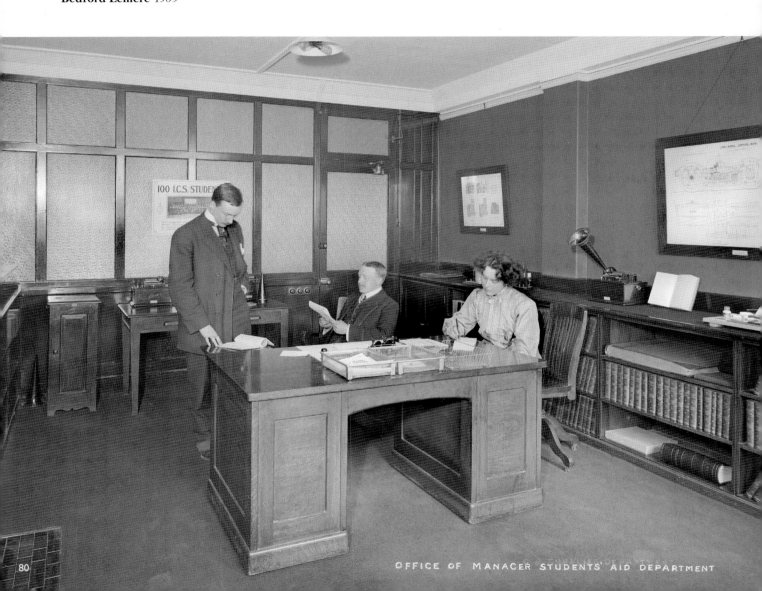

OFFICE OF MANAGER STUDENTS' AID DEPARTMENT

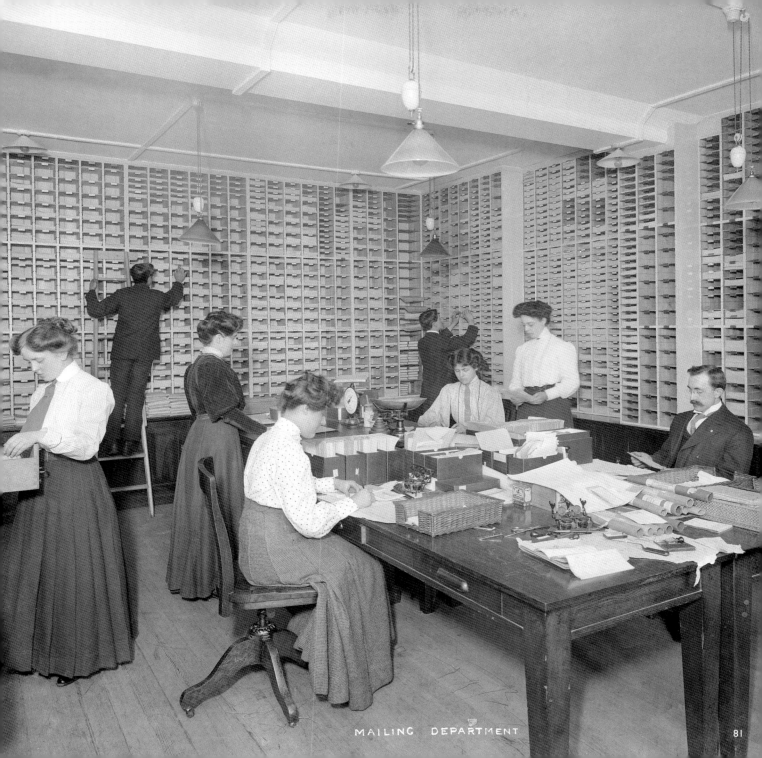

MAILING DEPARTMENT

The Enquiry Department at the
International Correspondence
School, Kingsway, London.
Bedford Lemere *1909*

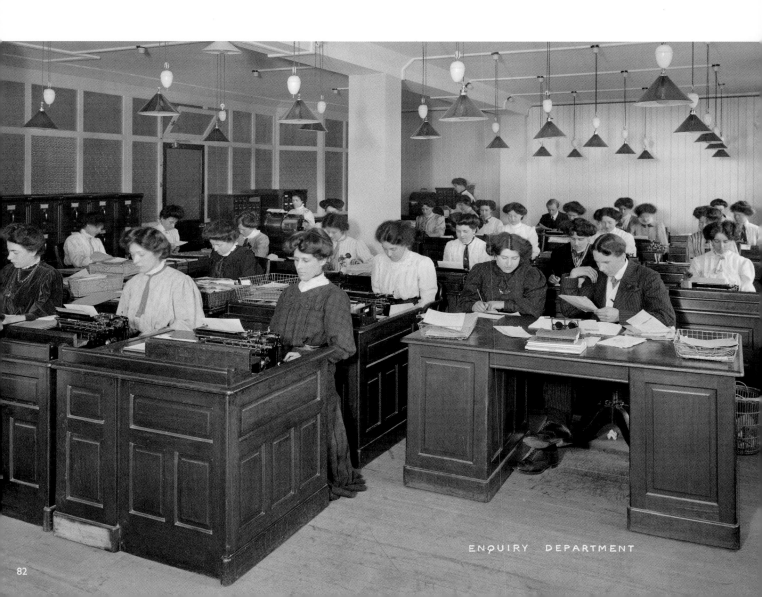

ENQUIRY DEPARTMENT

Processing forms for new students
at the International Correspondence
School, Kingsway, London.
Bedford Lemere *1909*

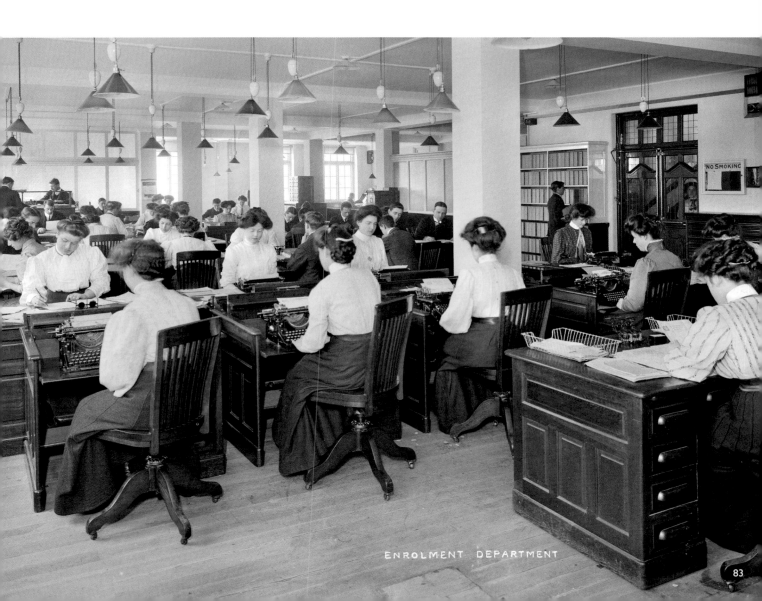

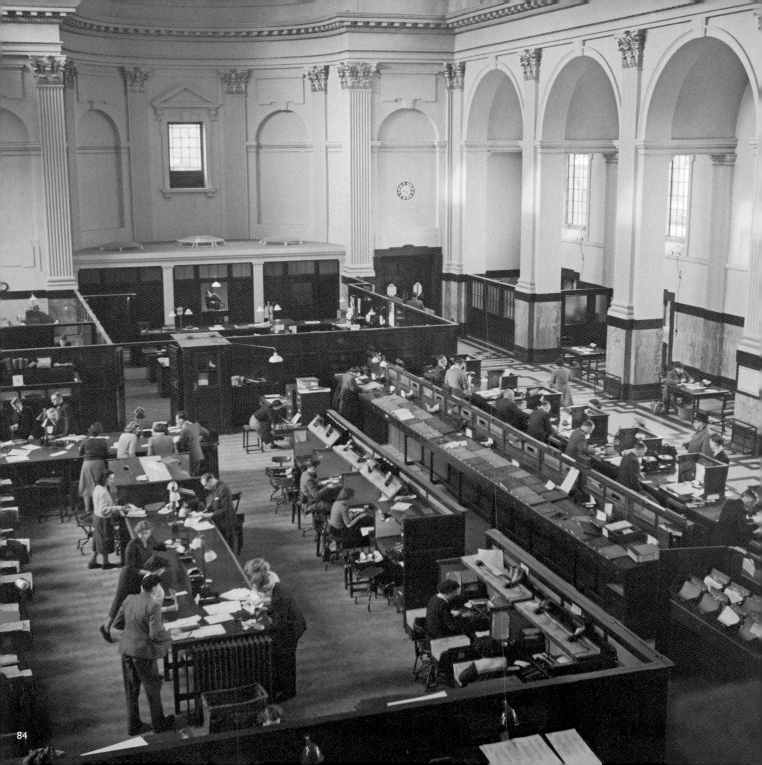

The banking hall at Barclays Bank,
Norwich, Norfolk.
Hallam Ashley *1951*

A group photograph of staff at the
International Correspondence
School, Kingsway, London.
Bedford Lemere *1909*

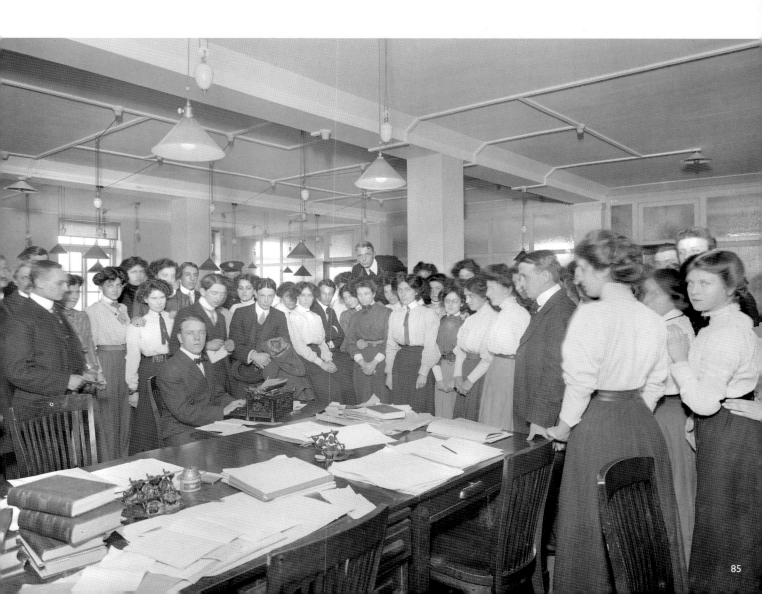

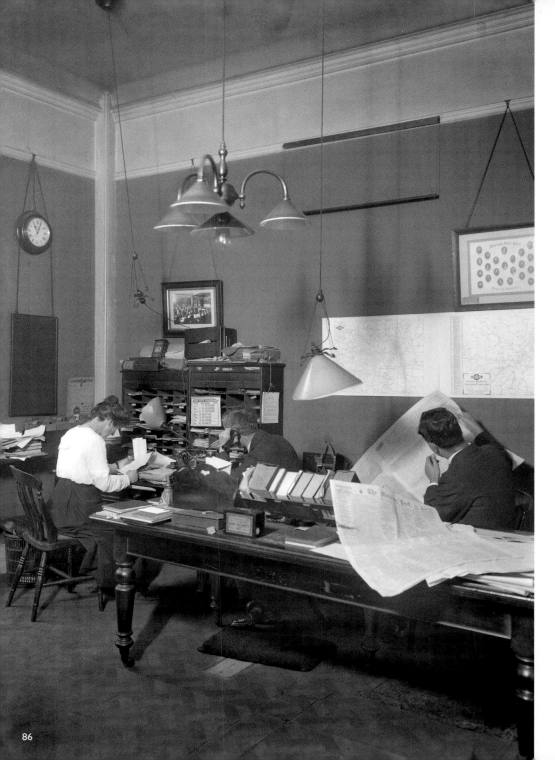

A *Morning Post* office strewn with paperwork and books needed to run a 1920s' newspaper.
Bedford Lemere
November 1920

Taken at 8.40am, these men are working on the next edition of *The Morning Post* newspaper, in London.
Bedford Lemere
November 1920

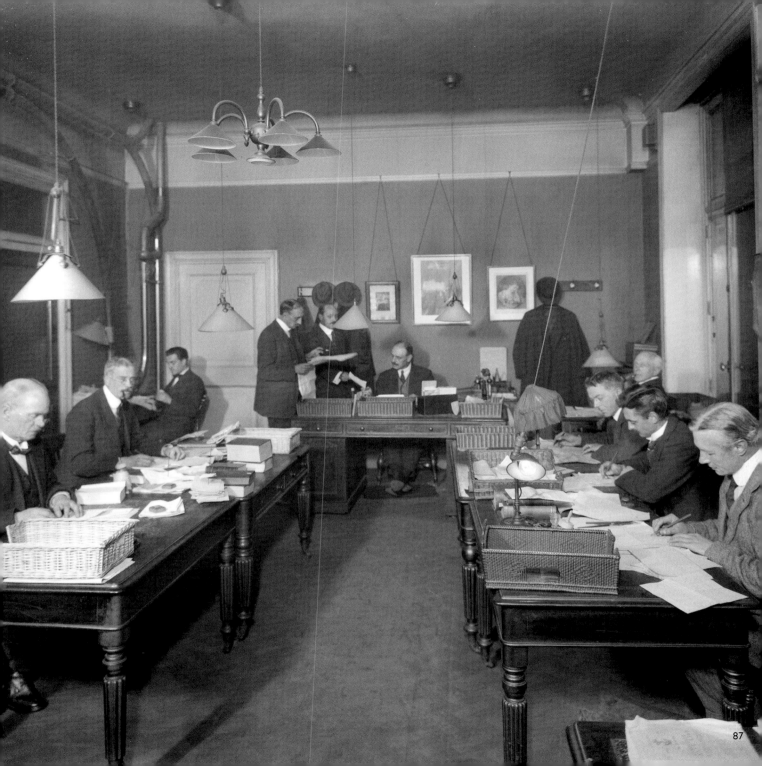

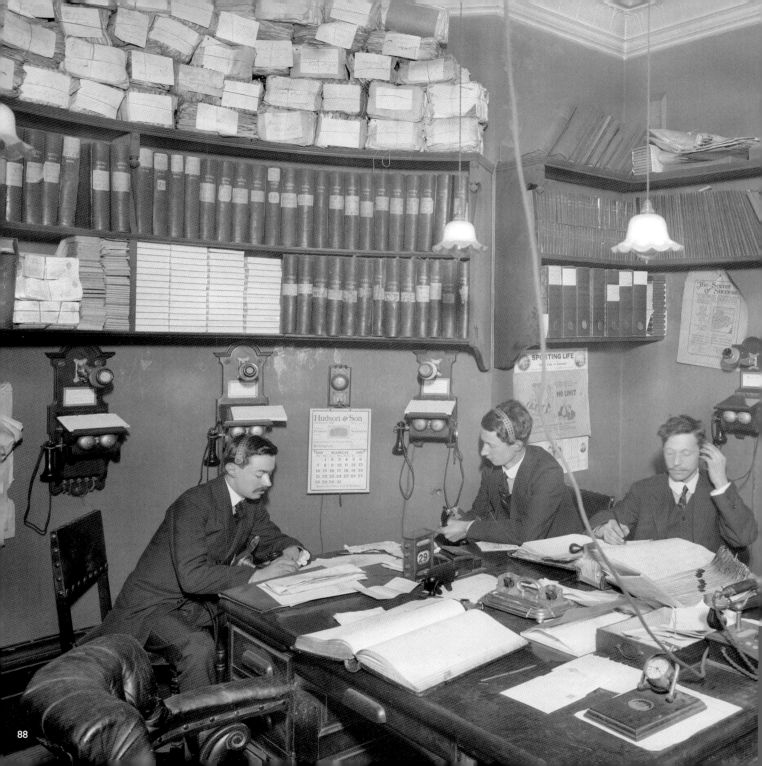

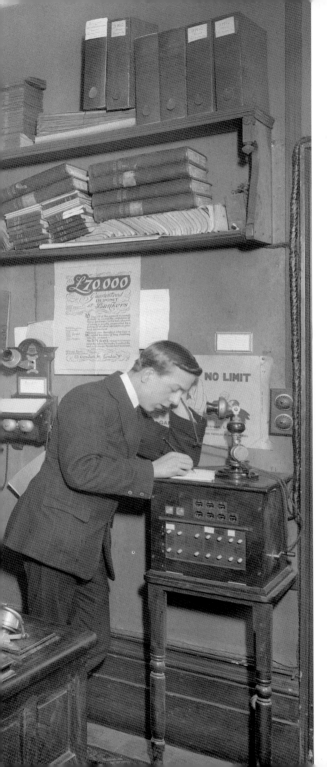

A view of a DL Grant's
crowded offices in
Conduit Street, London.
Bedford Lemere
29 March 1909

RETAIL

"PARAFFIN Bob used to come round on a really heavy cart pulled by the finest Shire horse, with all the trimmings, brasses and everything. He used to sell paraffin, pots and pans, dolly blue, Robin starch – everything you might need. His cart was festooned with pots, pans and brushes. He used to ring a bell to let you know he was coming, but he didn't need to – you could hear him coming miles off."

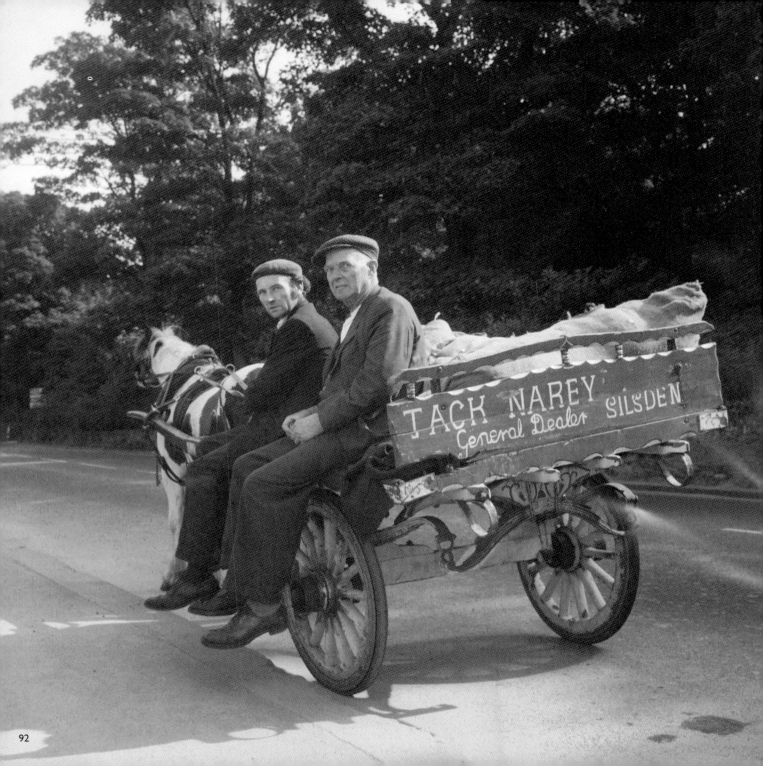

Jack Narey, general dealer, on his horse and cart in Silsden, West Yorkshire.
Eileen 'Dusty' Deste
1960-1974

A porter at Smithfield Meat Market, London.
Photographer unknown

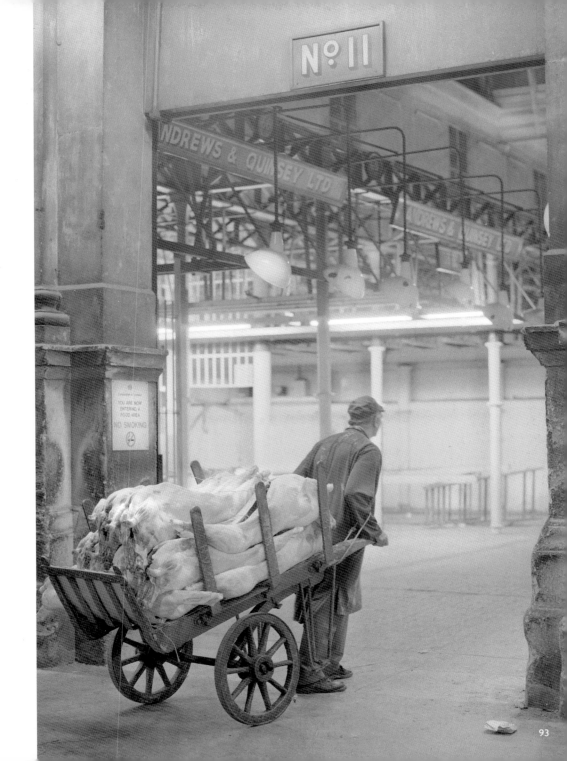

93

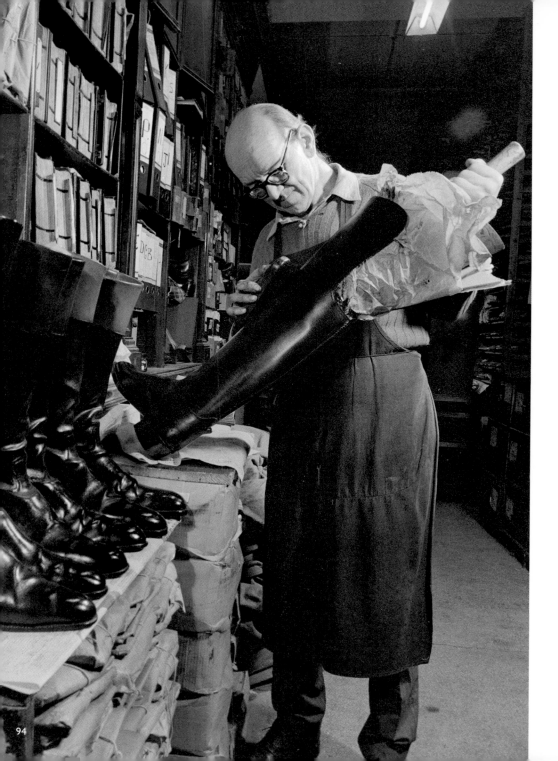

A portrait of Mr Eric Lobb, working in the family firm of John Lobb Ltd, boot and shoe makers, St James Street, London.
John Gay *1946-1959*

A shoe shine in Piccadilly Circus, London.
John Gay *1960s*

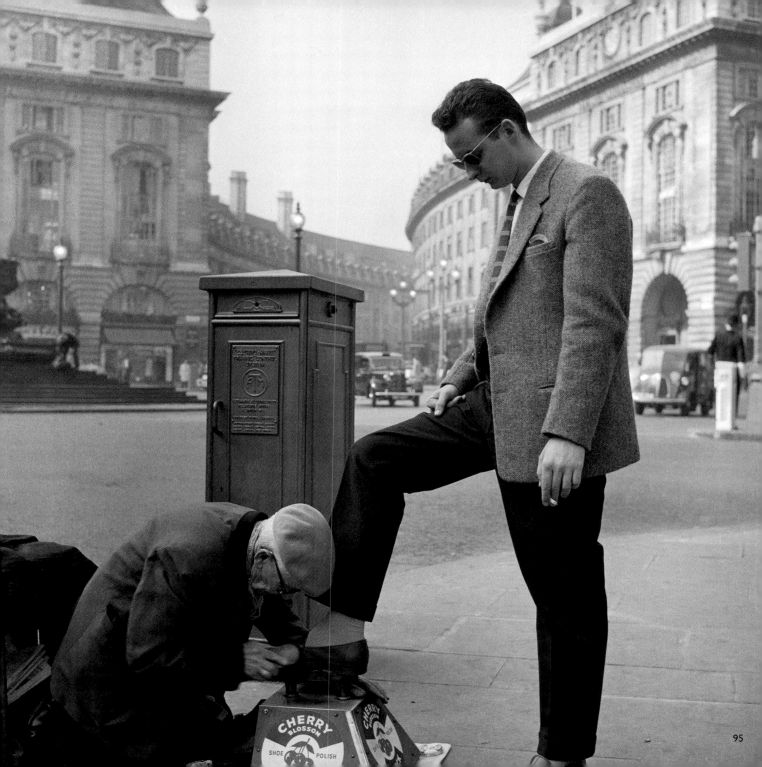

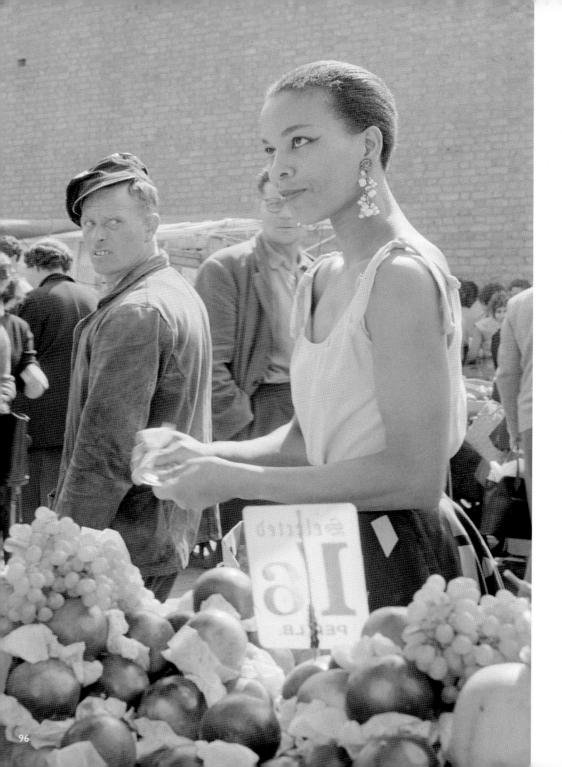

Buying fruit from a market stall in North London.
John Gay *1946-1959*

A shop keeper stands in the doorway of her premises at Shepherd Market, London.
John Gay *1950-1965*

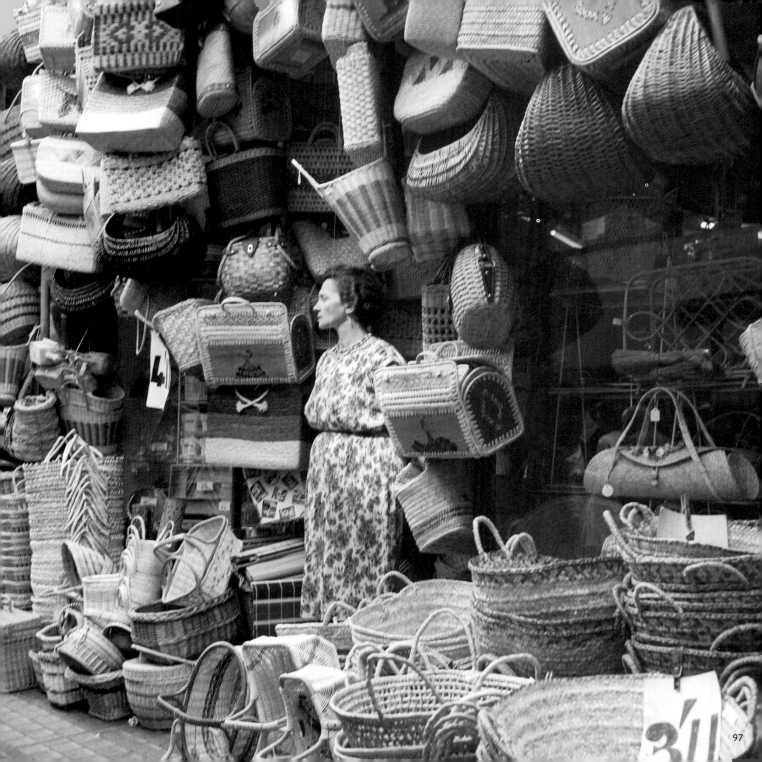

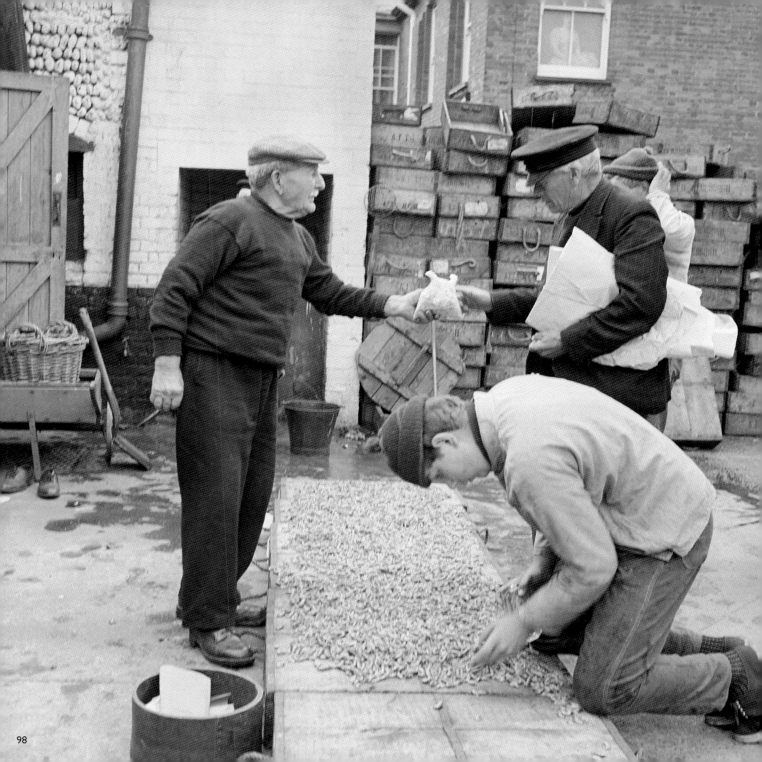

Fishermen selling
shrimps at Aldeburgh,
Suffolk.
John Gay *1964*

Porters at Billingsgate
Fish Market on Lower
Thames Street in the
City of London.
John Gay *1946-1959*

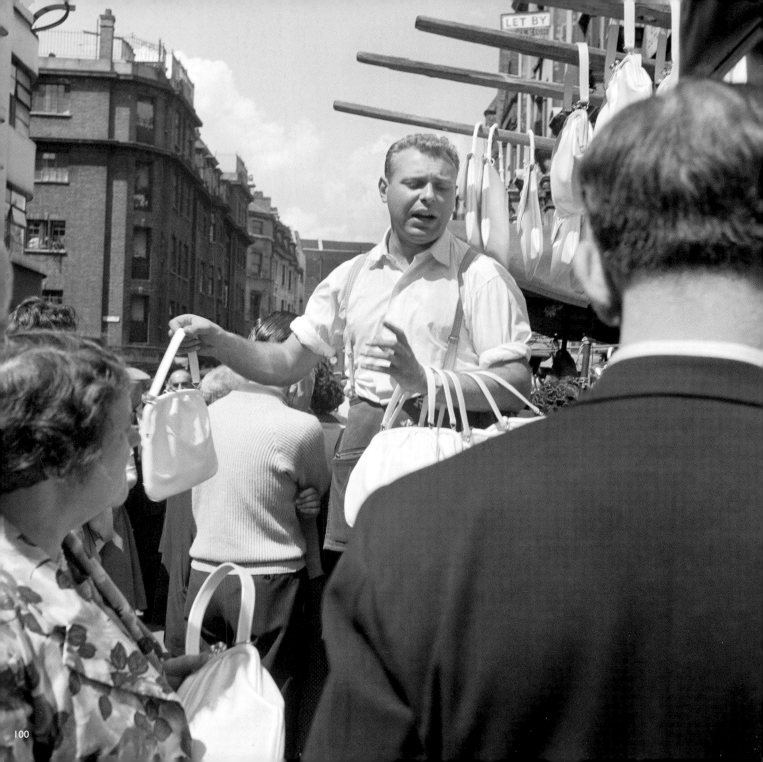

A market trader, Petticoat
Lane Market, London.
John Gay *1955-1965*

A newspaper vendor
in a London park.
S W Rawlings *1945-1965*

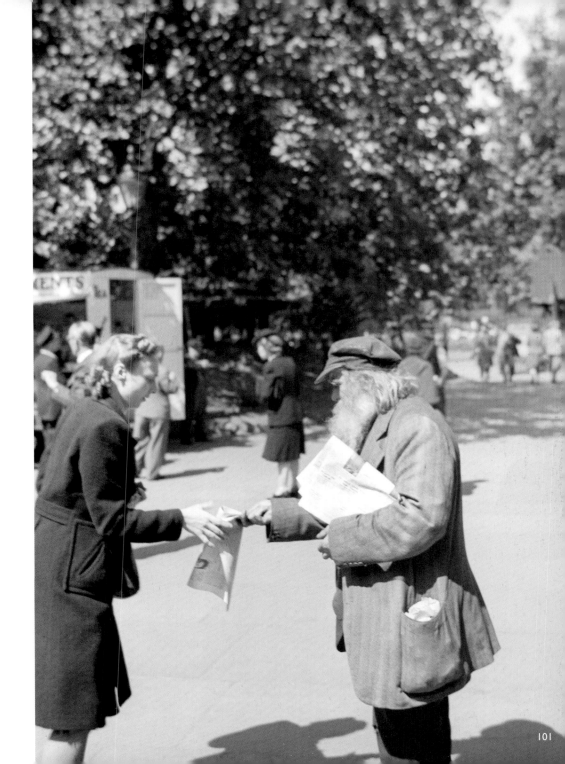

Waitresses serve afternoon
tea at Wood's Restaurant
in Berwick-upon-Tweed.
Alfred Newton and Son *1902*

Mrs Bailey's Pie Shop at
15 Webber Street, Falmouth,
Cornwall.
Alfred Newton and Son *1907*

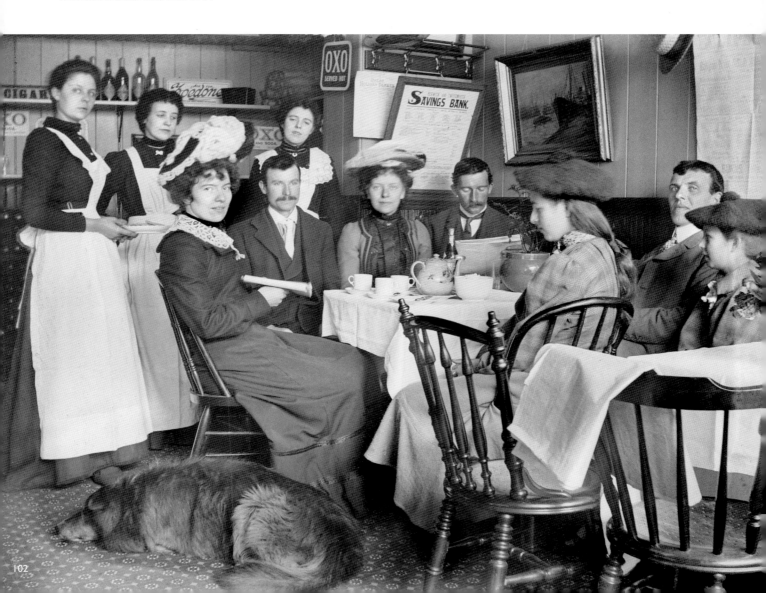

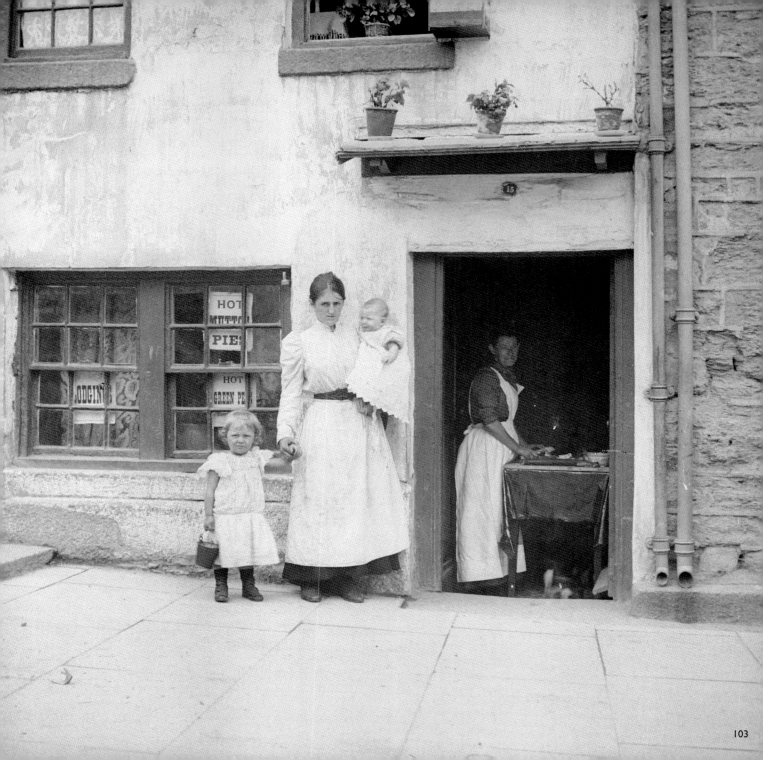

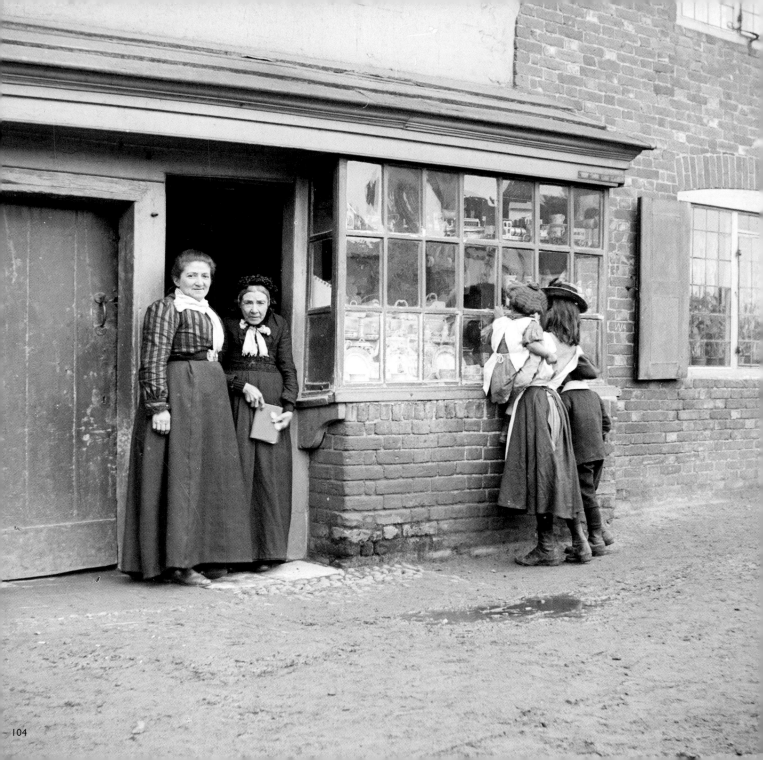

Miss Emma Clark and her mother stand in the doorway of their shop in Beaconsfield, Buckinghamshire.
Alfred Newton and Son *1902*

The staff at Billingham and Keeley's Grocery Store in Stockport, Manchester.
Alfred Newton and Son *1903*

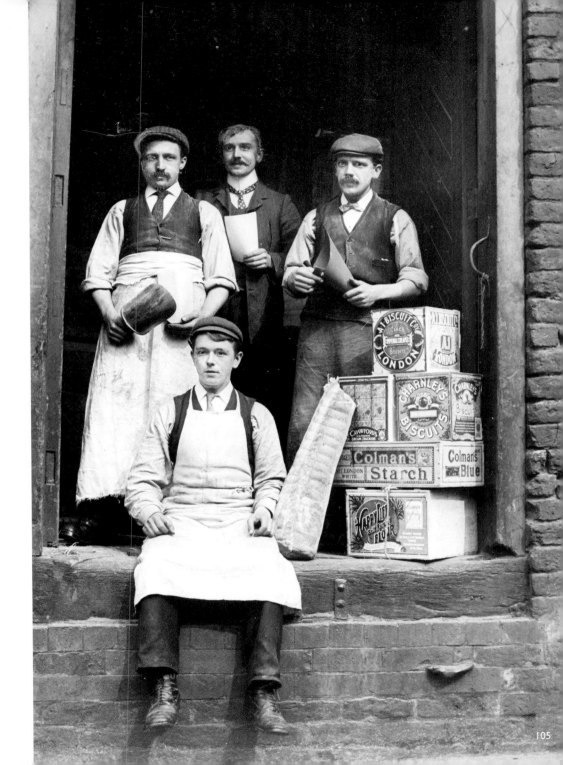

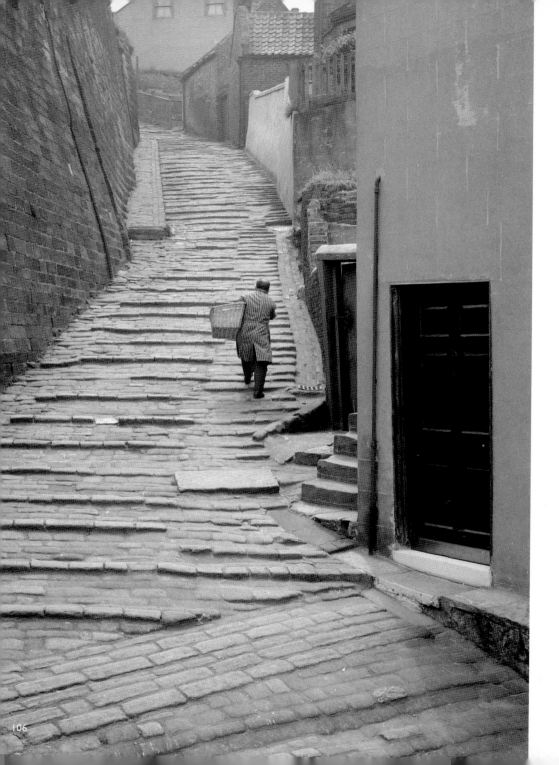

A baker making deliveries in Whitby, North Yorkshire. **Hallam Ashley** *1950s*

Market day at Chipping Camden, Gloucestershire. **Henry Taunt** *1895*

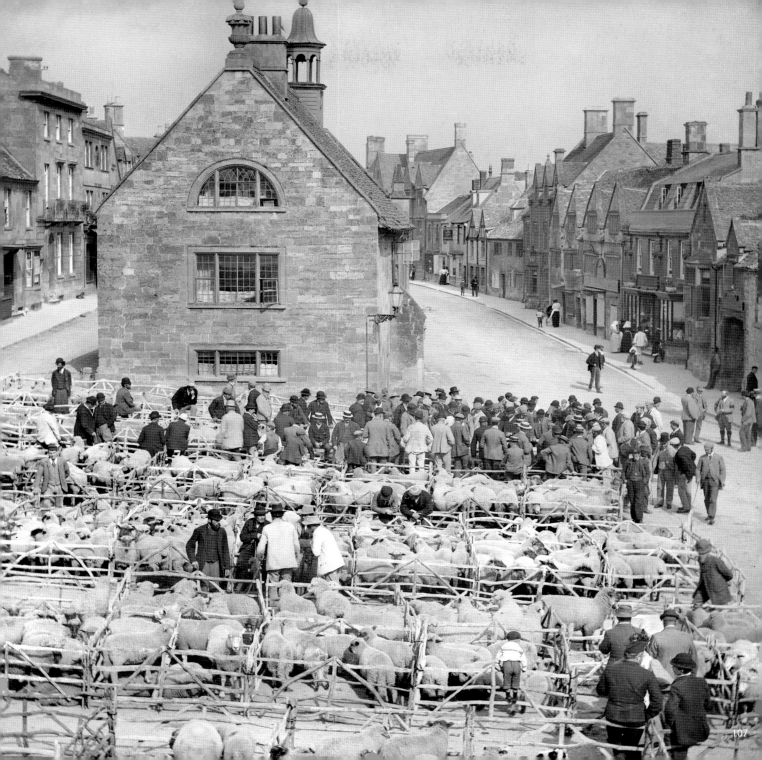

UNIFORMED
SERVICES

"LAW and order was looked after by the local village 'bobby'. Apart from a bit of poaching and apple scrumping he really did have a bobby's job as parental control was very strict and punishment was administered by your parents for any small misdemeanour."

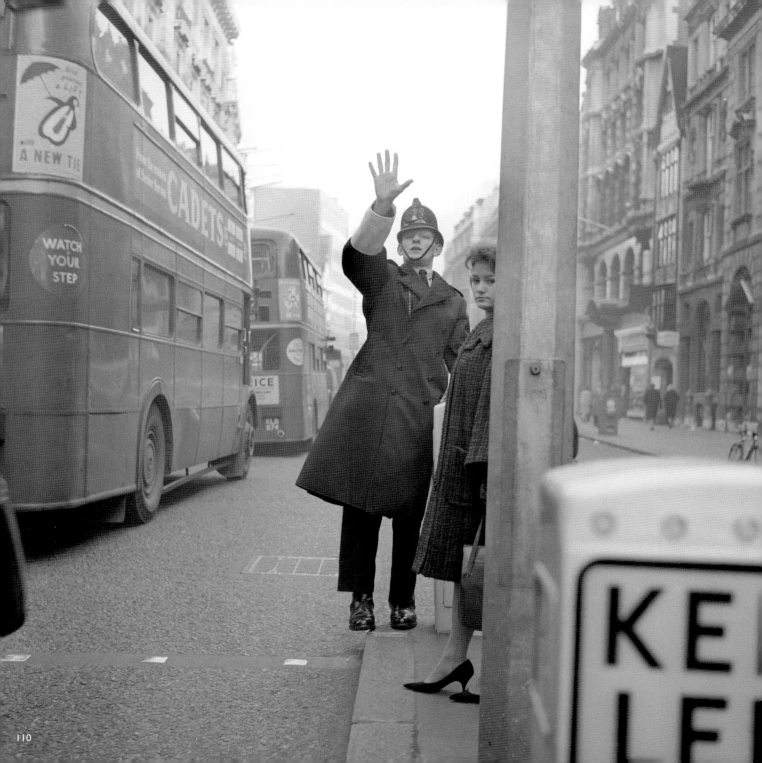

A policeman helps a lady
cross a busy London street.
John Gay *1946-1959*

A Port of London Authority
policeman checks a construction
lorry for security purposes.
S W Rawlings *1945-1965*

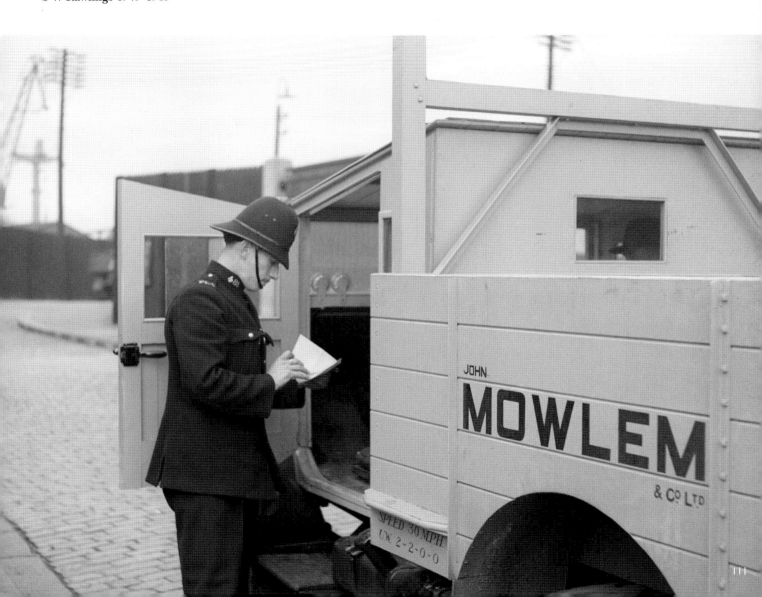

111

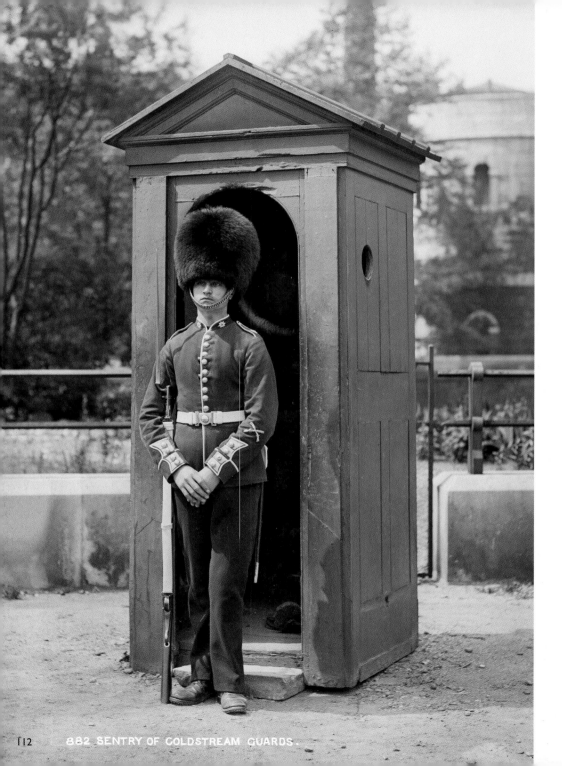

A Coldstream Guard
at the Tower of London.
York and Son *1870-1900*

An officer making a
telephone call onboard ship.
S W Rawlings *1945-1965*

882 SENTRY OF COLDSTREAM GUARDS.

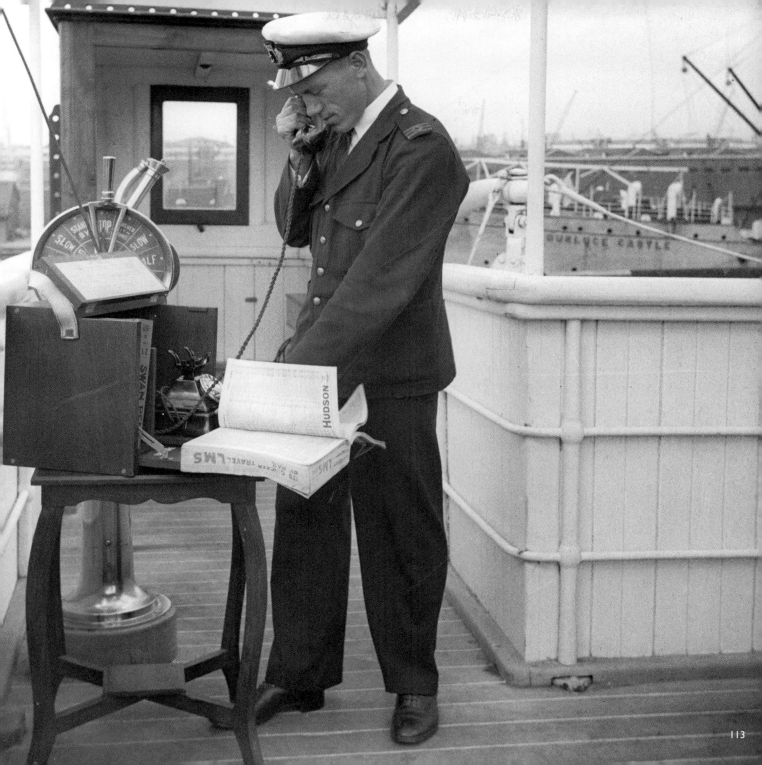

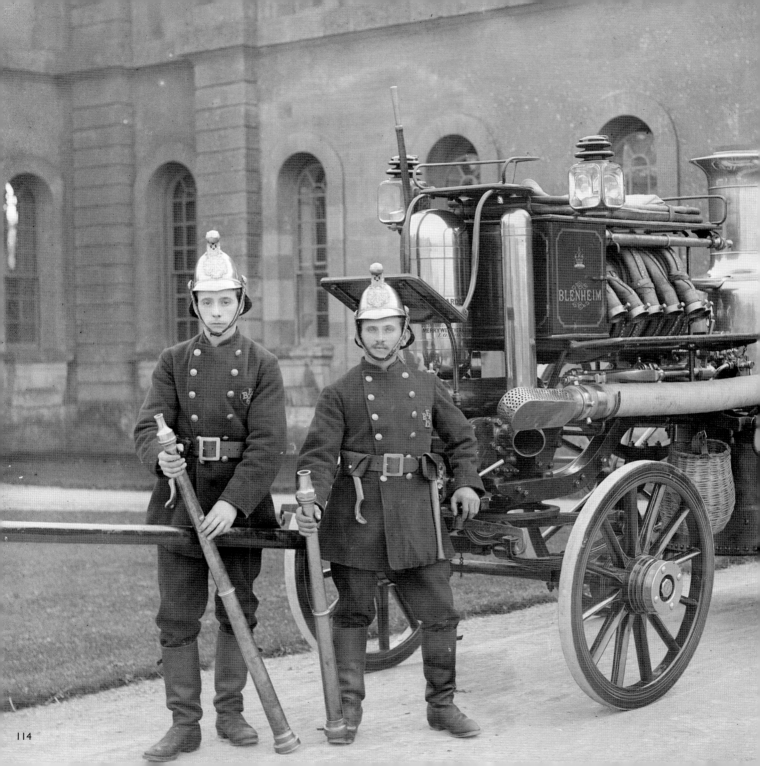

Blenheim Palace's own
fire engine in action.
Oxfordshire.
Henry Taunt *1860-1922*

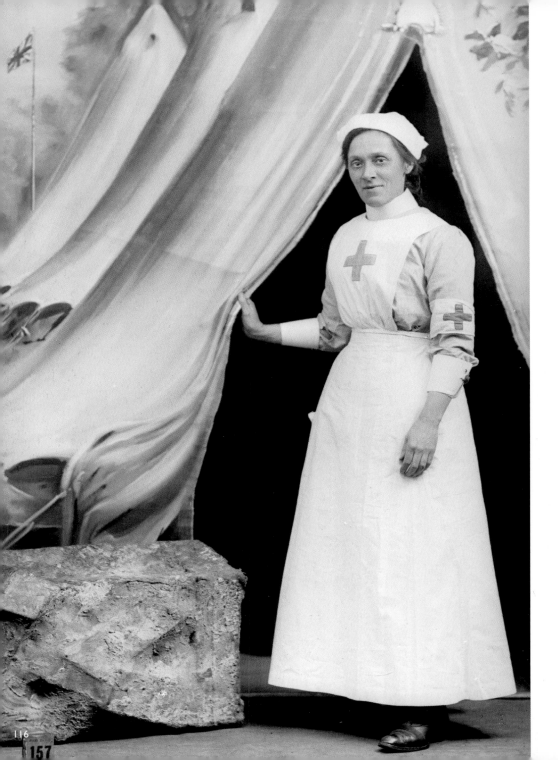

A studio portrait of
a nurse in uniform.
Alfred Newton and Son
1896-1920

Convalescing soldiers pose
in uniform at Great Dixter,
Northiam, East Sussex.
Nathaniel Lloyd
December 1915

157

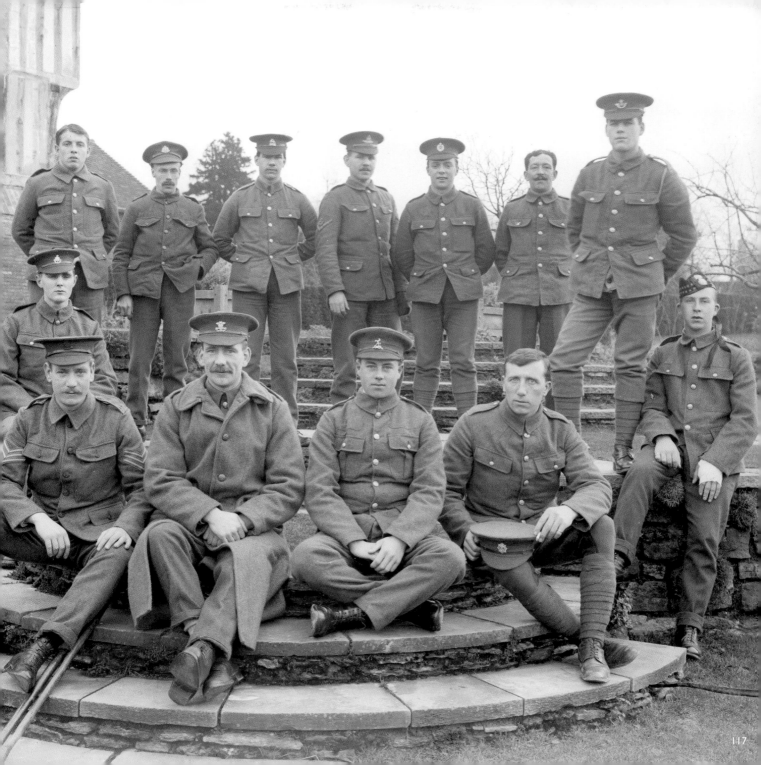

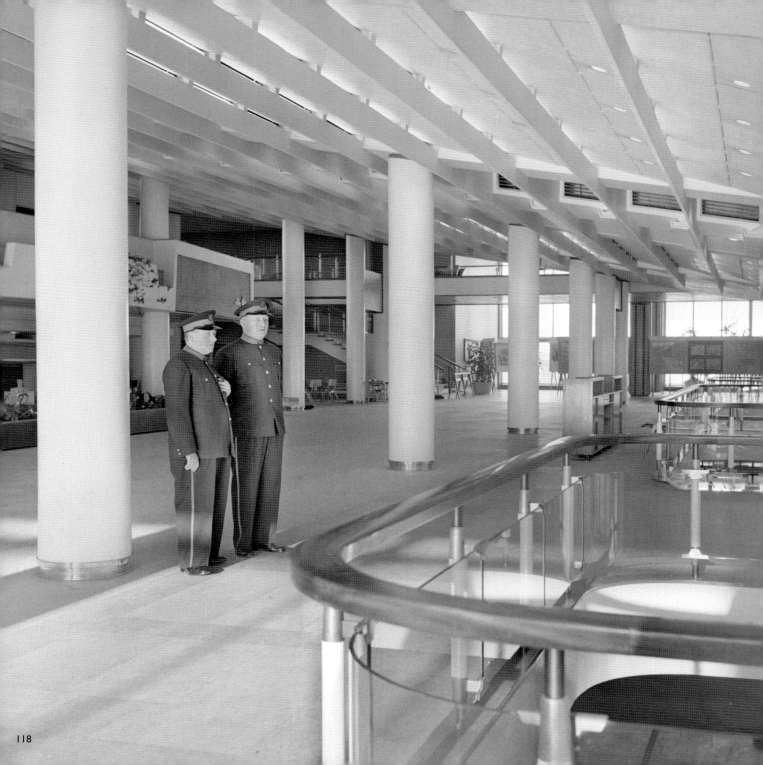

Commissionaires in the foyer at
the Royal Festival Hall, London.
Eric de Maré *1951-1962*

Uniformed lift attendants at
Selfridges department store,
Oxford Street, London.
Sydney W Newbery *c1928*

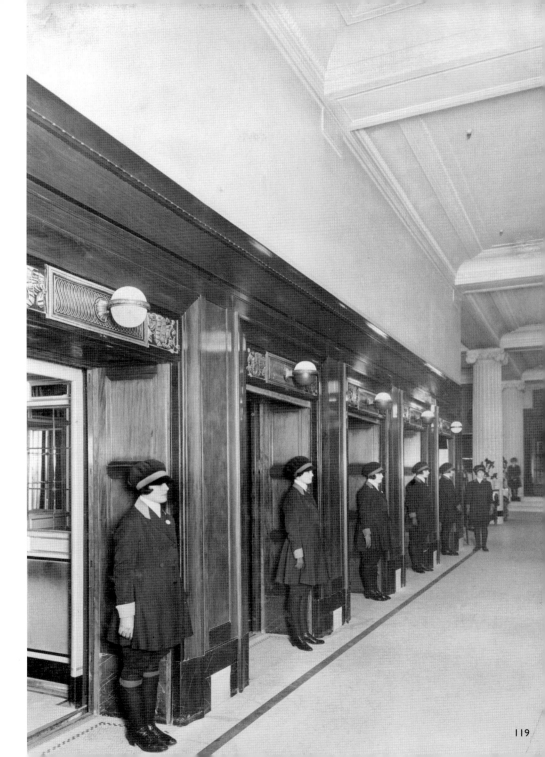

A portrait of staff and warders
at Nottingham Prison,
Nottinghamshire.
Photographer unknown *1891-1900*

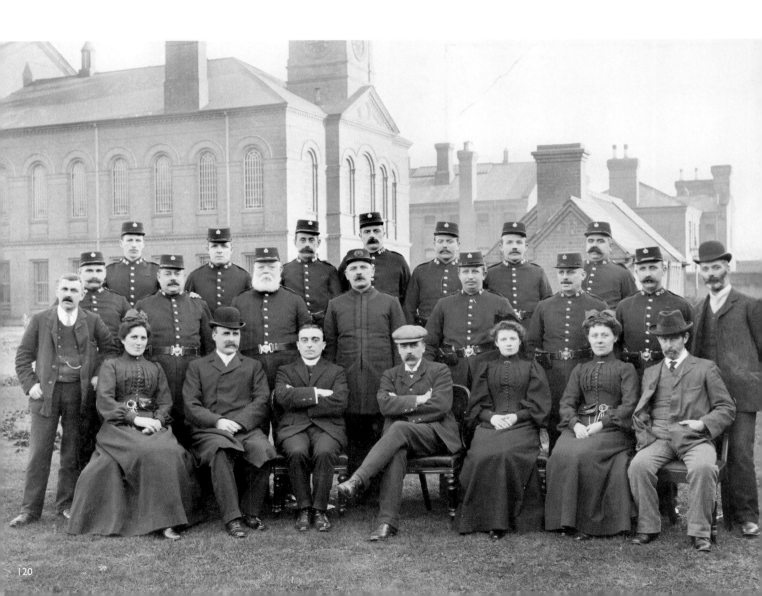

Staff at the Odeon cinema on
London Road, Isleworth, London.
John Maltby *1935*

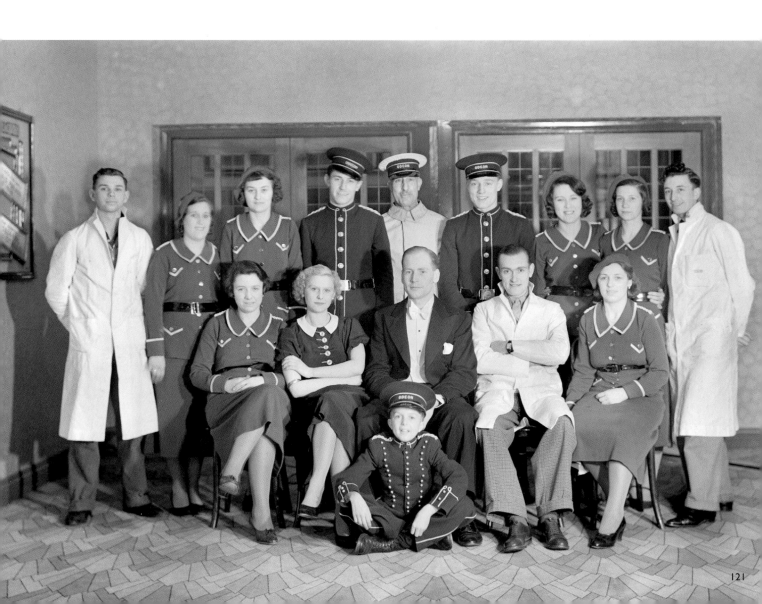

A coastguard keeping watch near
Hartland Point lighthouse, Devon.
Alfred Newton and Son *1896-1920*

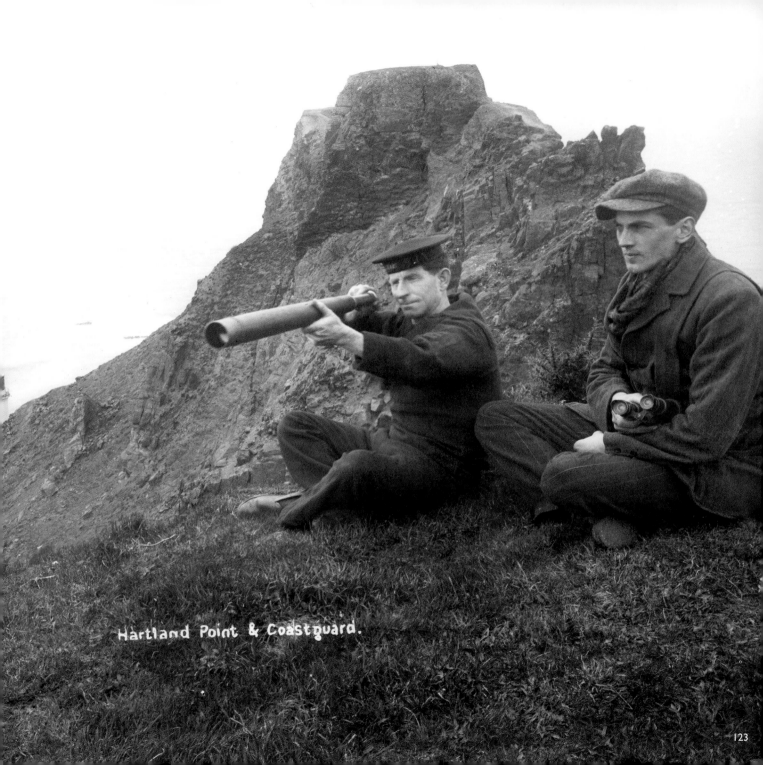

Hartland Point & Coastguard.

123

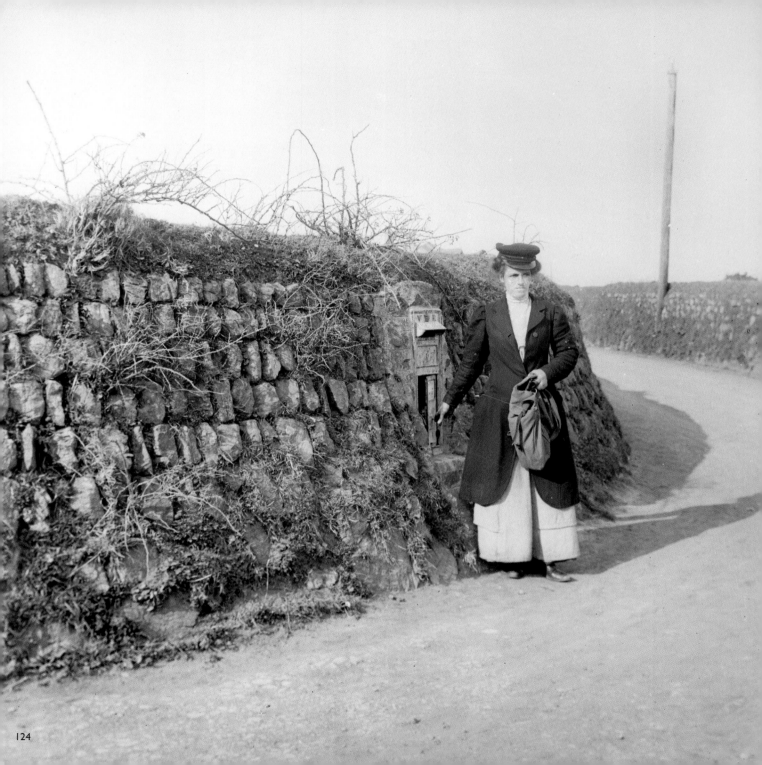

A post lady emptying a post box
in Kerrier, Cornwall.
Alfred Newton and Son *1901*

A team of postmen and women
at Byfield, Northamptonshire.
Alfred Newton and Son *1896-1920*

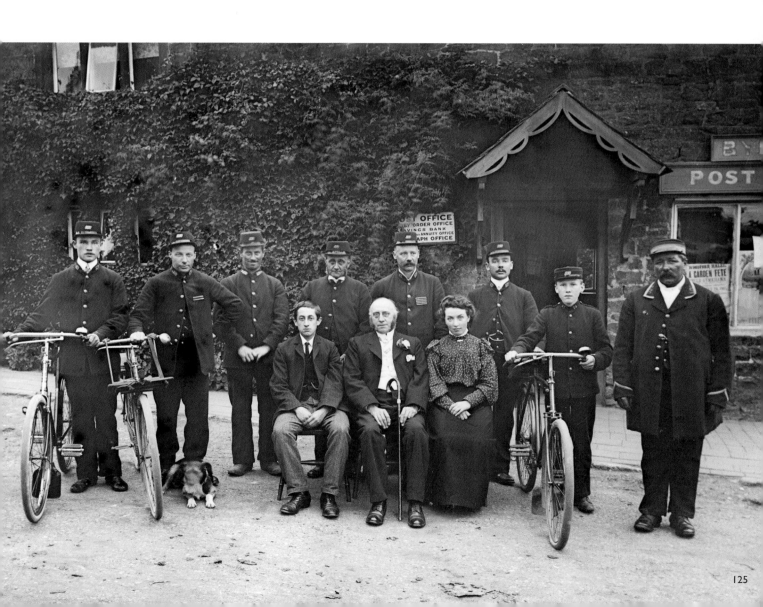

TRANSPORT

"*I* WAS *the fireman on the Beyer Garrett Engine. It was the most powerful engine in the country. It was unusual, it had a water tender in front and coal tender at the back. I shovelled coal into the fire hole all the time. My years on the railways developed an interest in trains and I'm still a steam train buff to this day. It never leaves you.*"

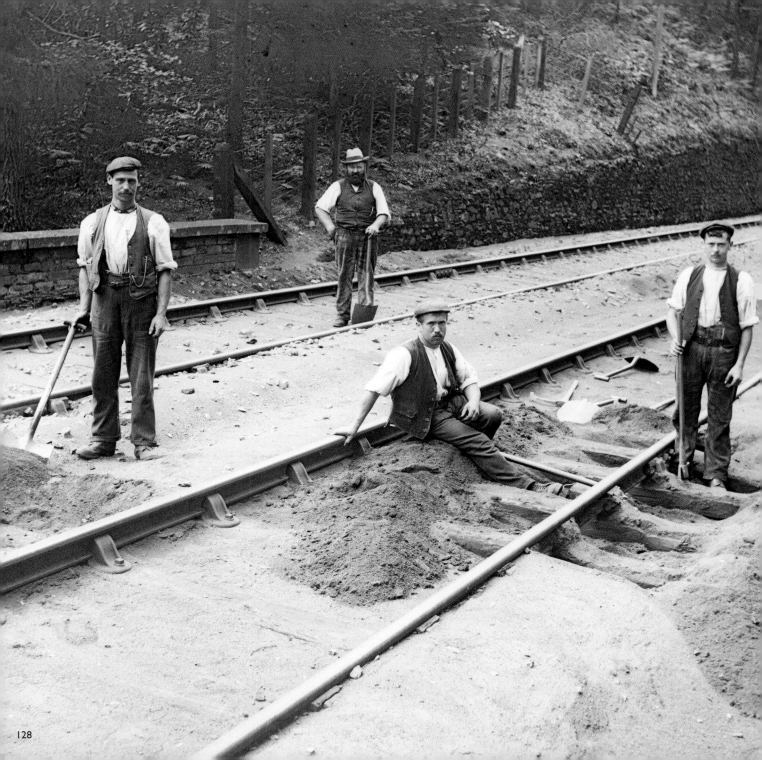

Tracklayers on the Great
Western Railway at Bodmin
Road Station, Cornwall.
Alfred Newton and Son *1901*

A pilot transfers between ships
at Gravesend Reach, Kent.
S W Rawlings *1945-1965*

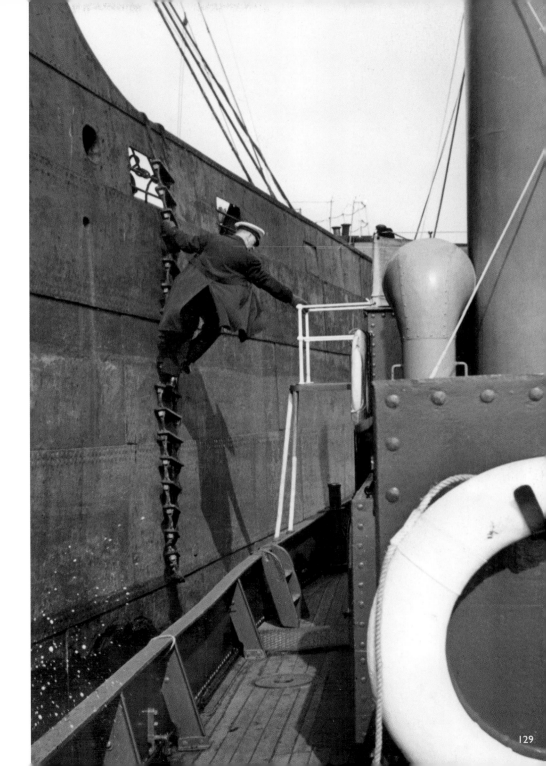

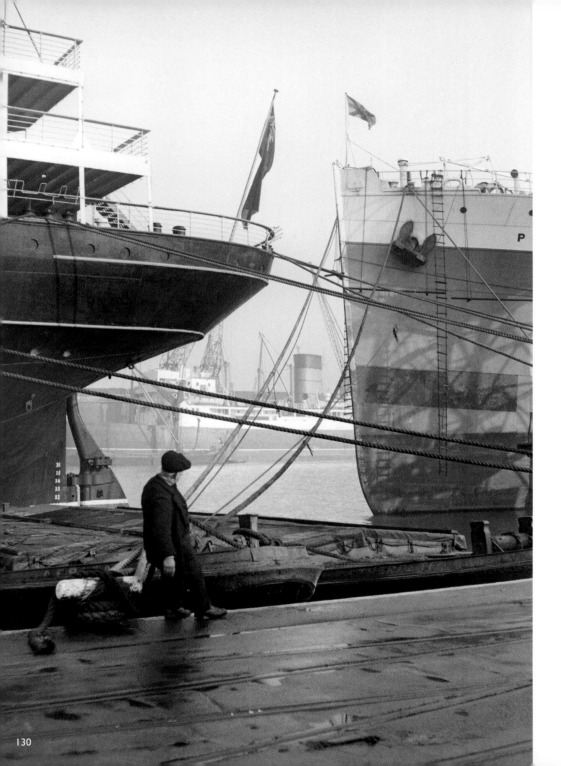

Securing a barge at the
Royal Albert Dock, London.
S W Rawlings *1945-1965*

A winchman in London Docks.
S W Rawlings *1945-1965*

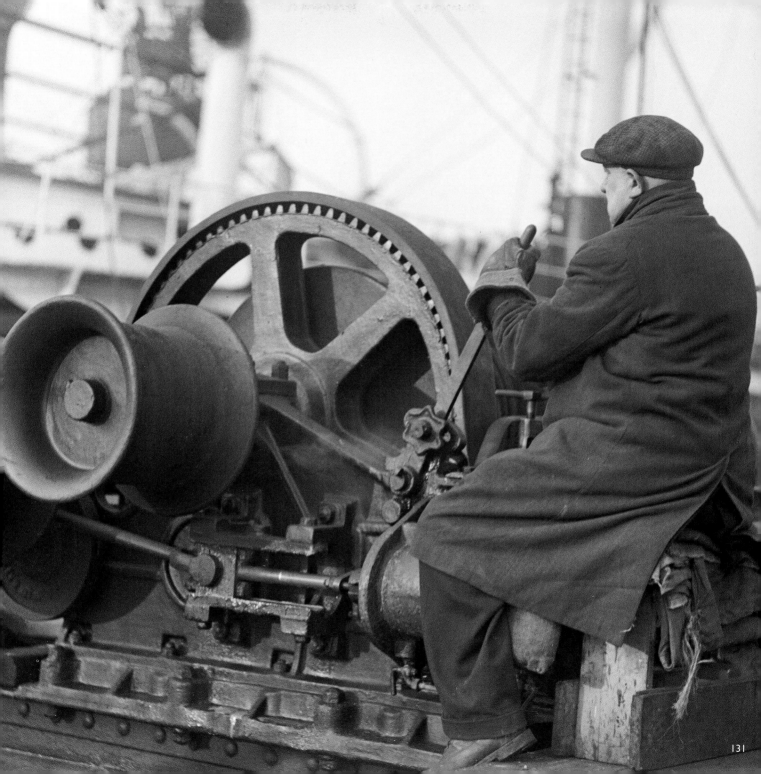

Two porters transporting suitcases
in the baggage hall of Tilbury
Passenger Landing Stage, Essex.
S W Rawlings *1945-1965*

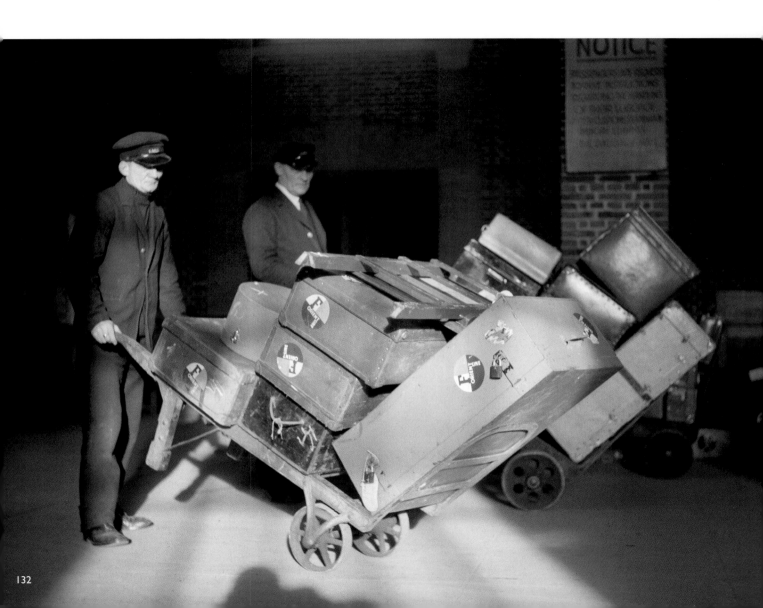

A porter at Charwelton Station
on the Great Central Railway,
Northamptonshire.
Alfred Newton and Son *1901*

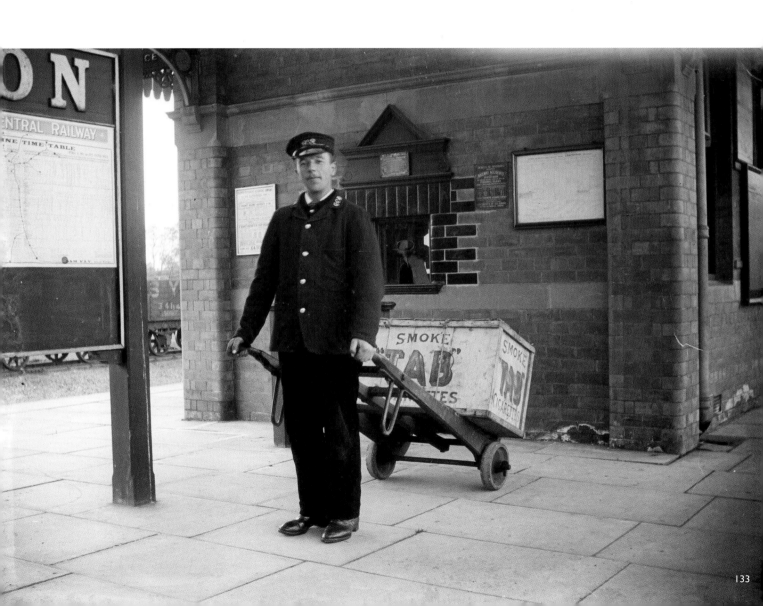

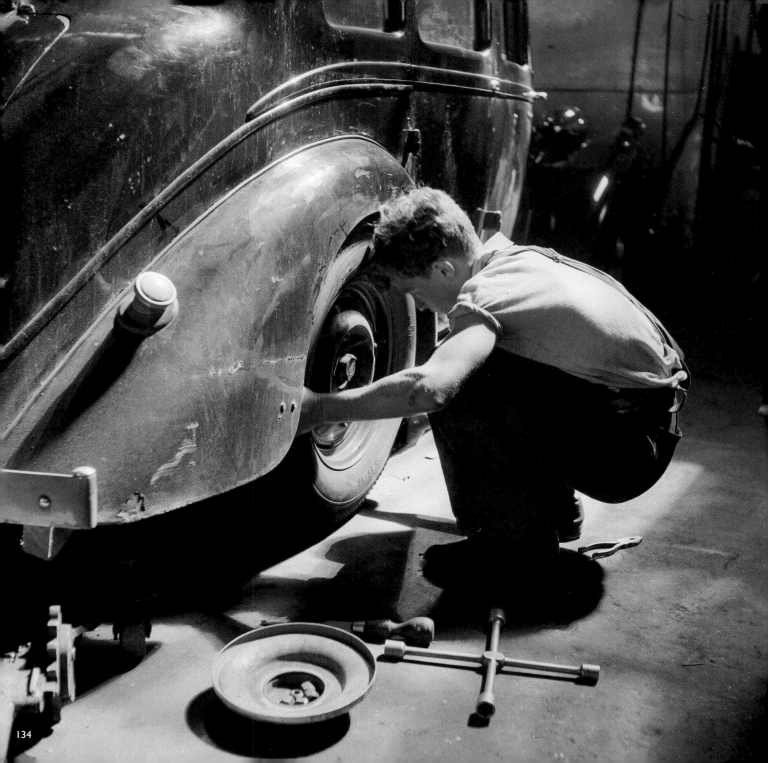

A mechanic changes the
wheel of a car at a Padstow
garage, Cornwall.
John Gay *1956*

An early motorised London
cab with its driver.
York and Son *1897-1900*

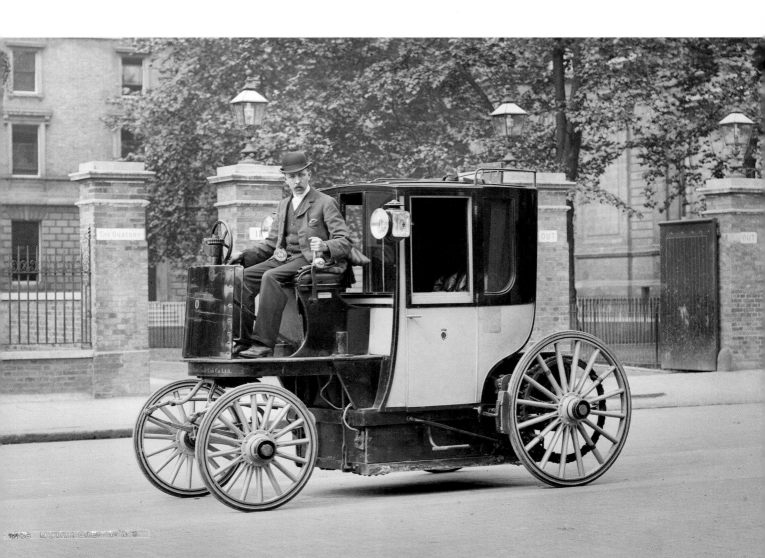

A coachman waits outside the
Royal Courts of Justice in London.
Campbell's Press Studio

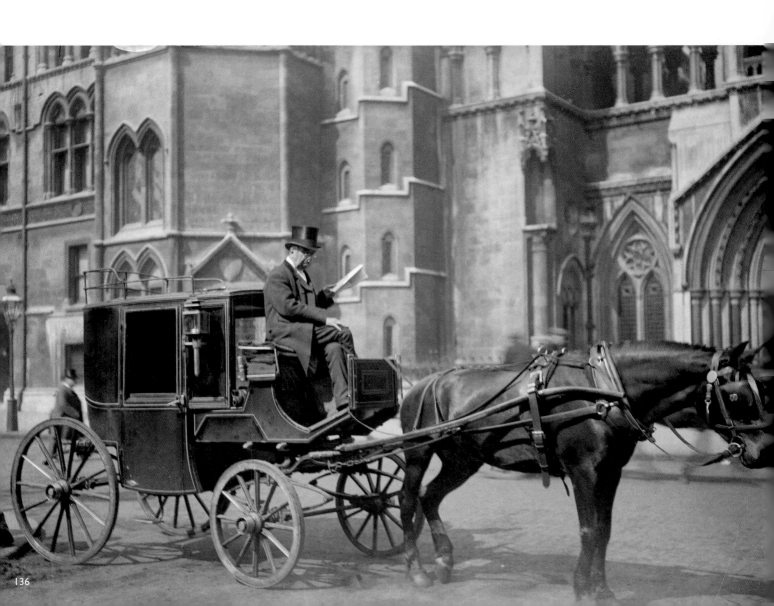

A man with his horse and cart
at Chetwode, Buckinghamshire.
Alfred Newton and Son *1901*

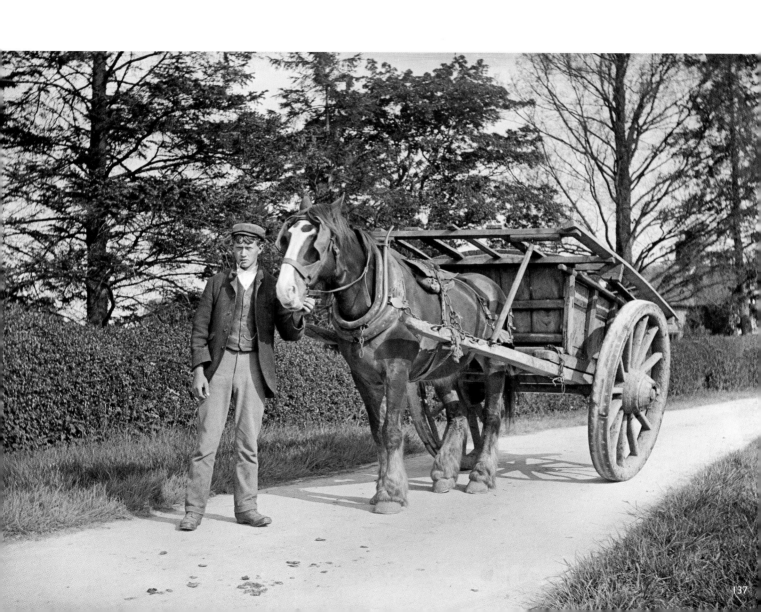

Isambard Kingdom Brunel's steamship the *Great Eastern* under construction at Blackwall, London.
Robert Howlett *1857*

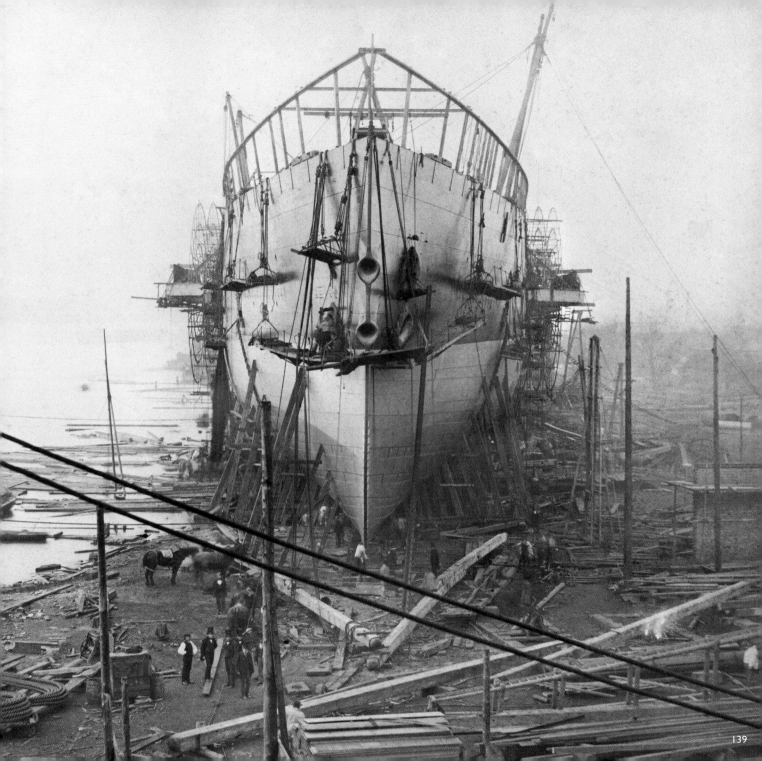

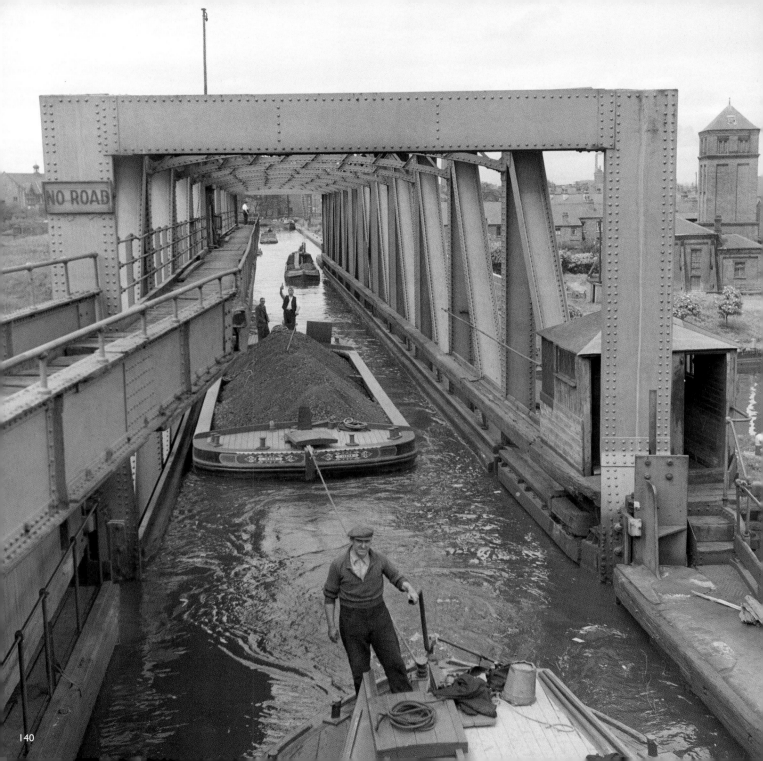

A barge loaded with coal crossing
the Barton Aqueduct on the
Bridgewater Canal.
Eric de Maré *1945-1980*

Repairing the Thames and Severn
Canal at Blue House Reach,
Siddington, Gloucestershire.
Henry Taunt *1904*

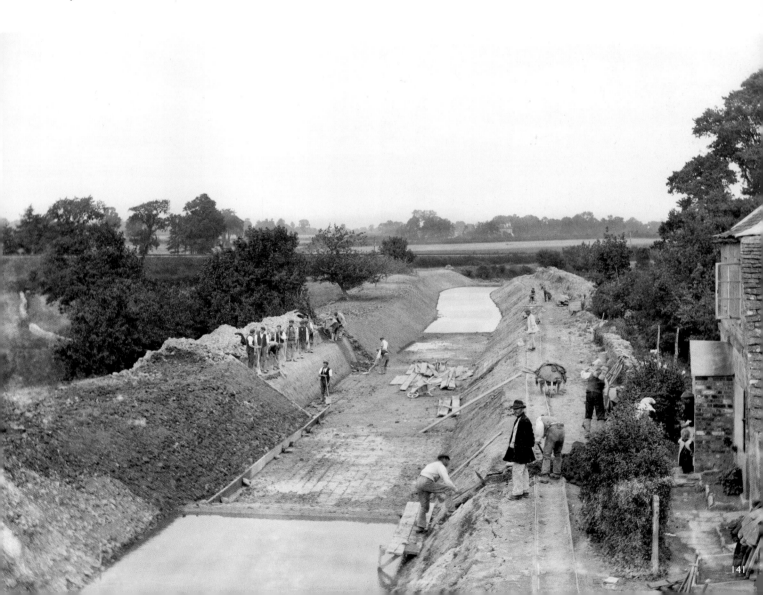

Waterman Abel Beesley on his punt
with a cargo of rushes, Fisher Row,
Oxford, Oxfordshire.
Henry Taunt *1901*

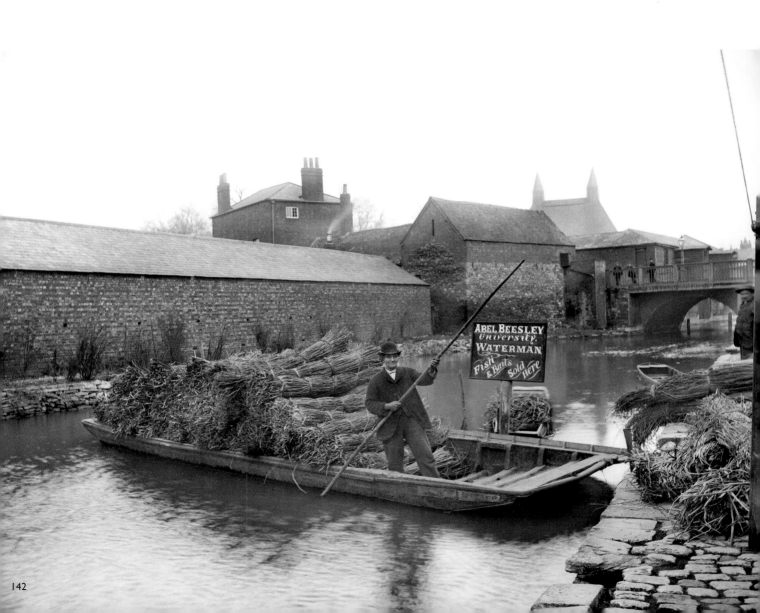

Workmen loading a river barge
at Marlow, Buckinghamshire.
Henry Taunt *1860-1922*

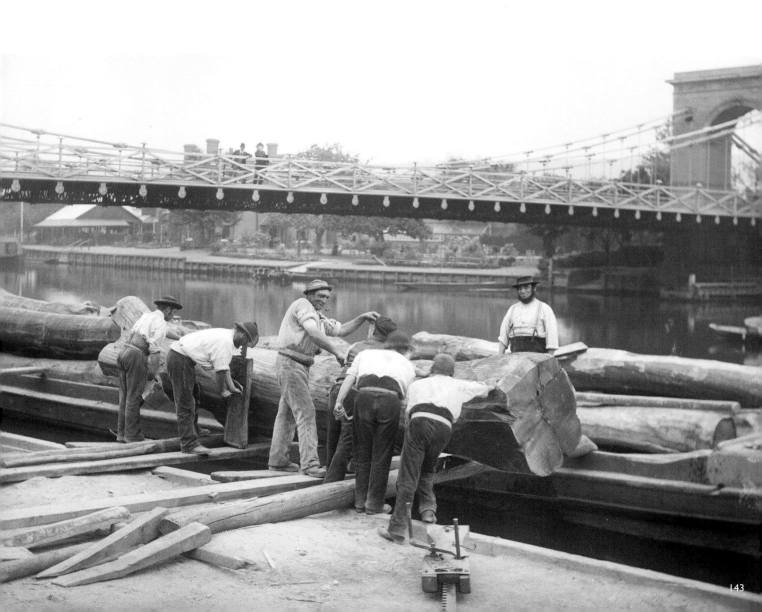

WAR WORK

"*DURING the war I used to work at a mill making parachute material. We had to live in hostels, we were mixed, men and women. The Americans used to hold dances at their bases. They used to fetch us women in army trucks to the dance. Of course it was all above board, no messing about, if you know what I mean.*

We weren't allowed to talk about what we were making at the mill. The material was strong and when you managed to get hold of a bit to make underskirts they lasted for years."

Making supplies for the military in the sewing workshop at Hampton's factory, Lambeth, London.
Bedford Lemere *1916*

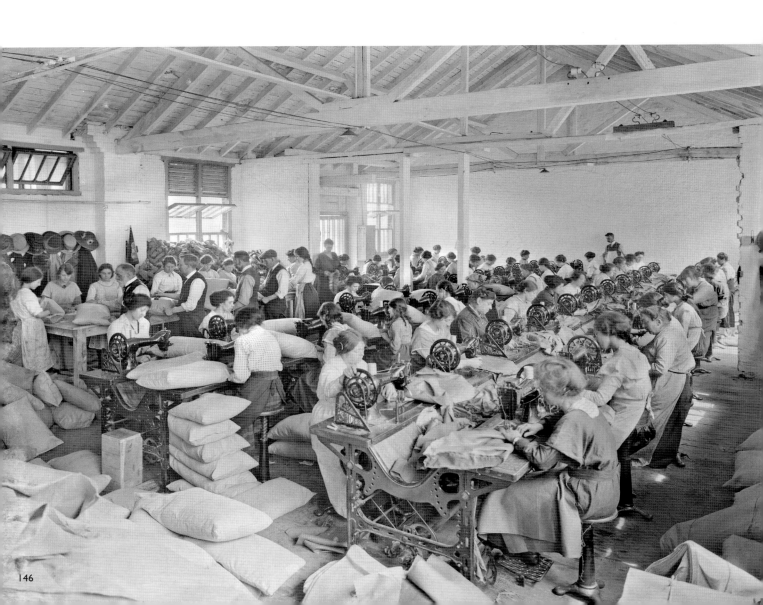

Making aircraft frames at
Waring and Gillow's furniture
factory in Liverpool, Merseyside.
Bedford Lemere *1918*

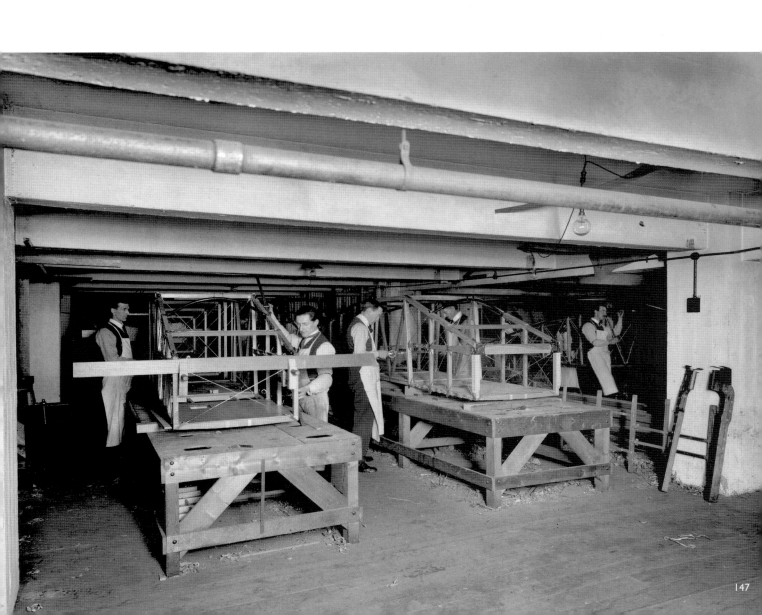

Hampton's furniture factory in
Lambeth, London, producing
aircraft propellers.
Bedford Lemere *1916*

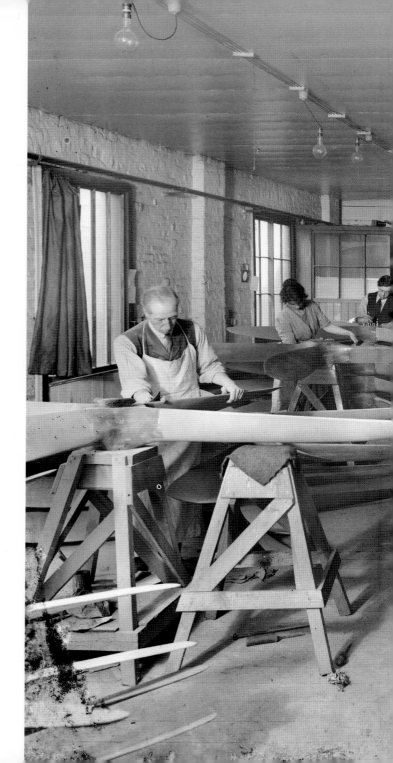

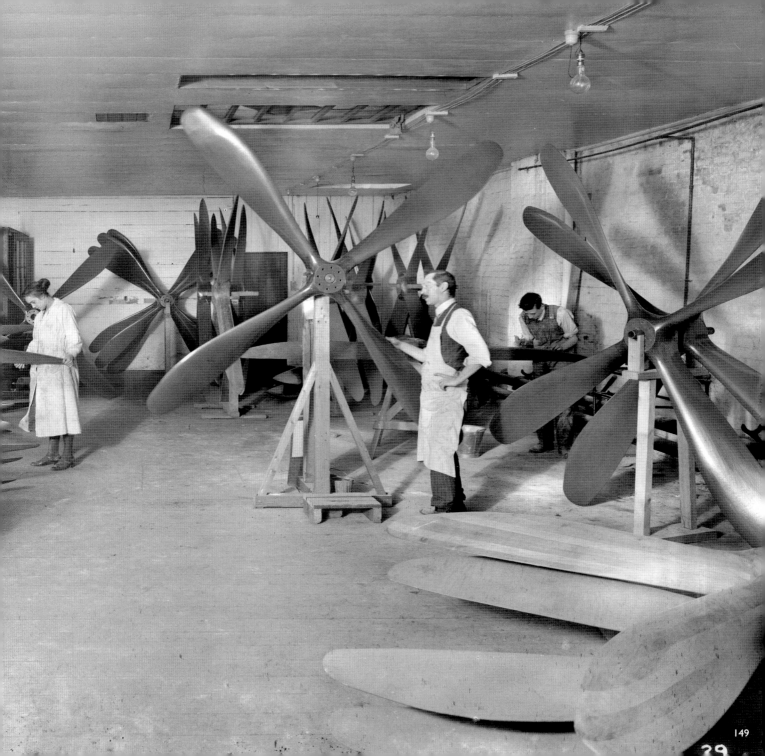

Preparing aircraft wings at the
Waring and Gillow furniture
factory, Lancaster.
Bedford Lemere *1917*

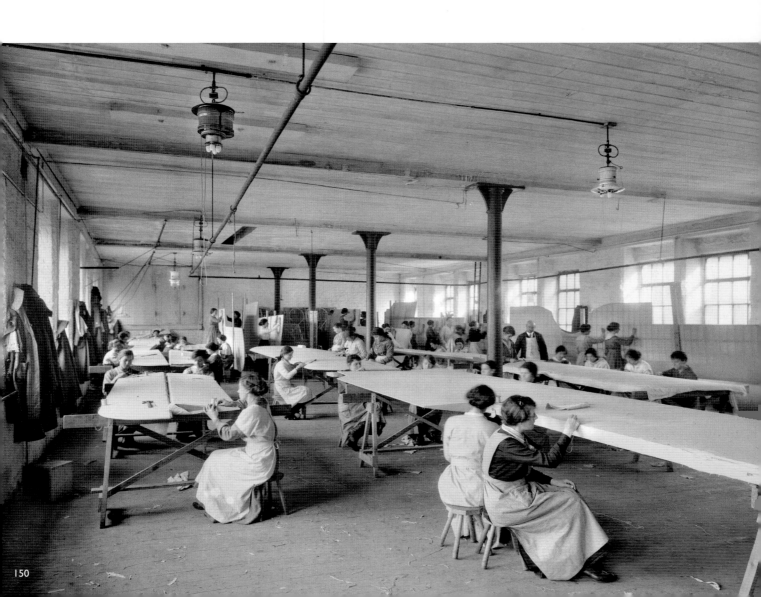

Painting markings on aeroplane
wings at Waring and Gillow's
factory, Hammersmith, London.
Bedford Lemere *1916*

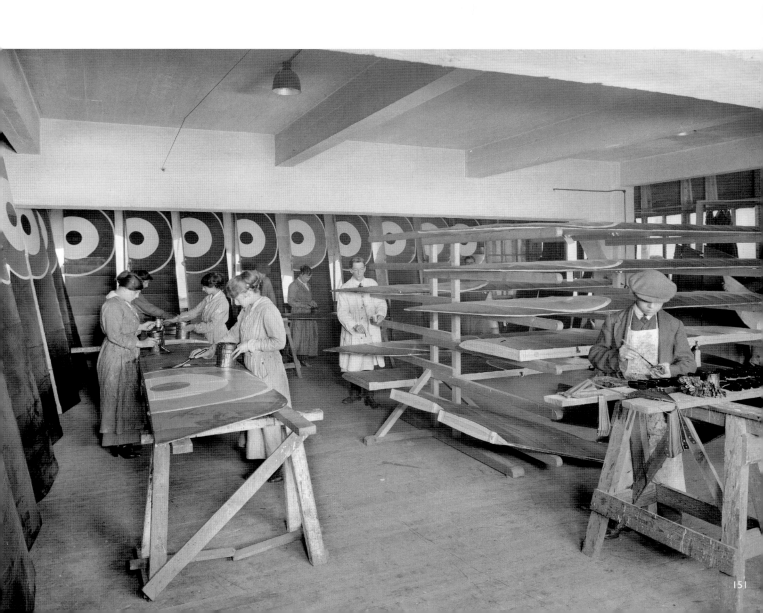

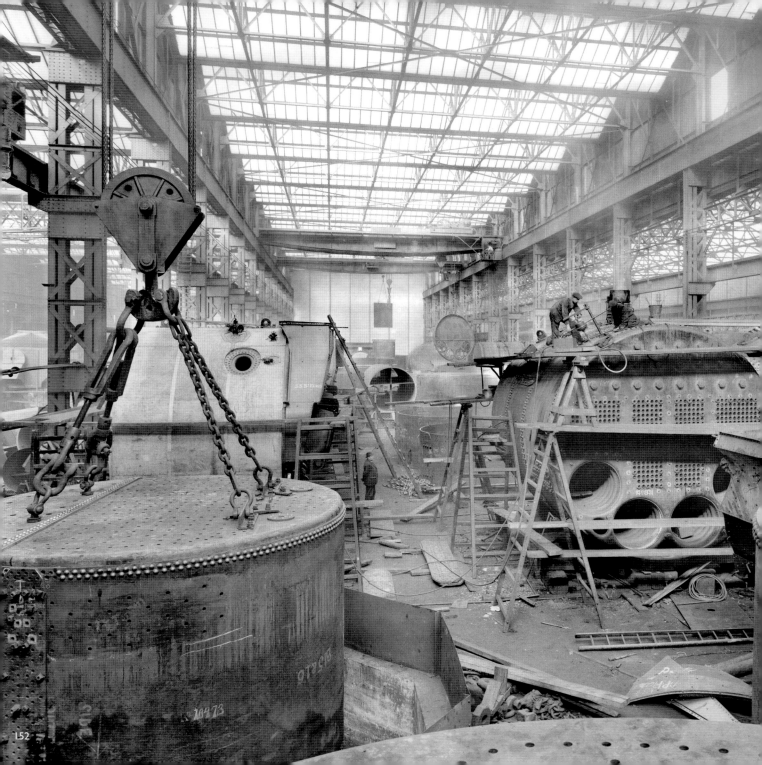

The boiler shop,
Cammel Laird shipyard,
Birkenhead, Merseyside.
Bedford Lemere *1914*

Two members of the Women's Land Army gather wood in East Devon.
Alfred Newton and Son *1917-1918*

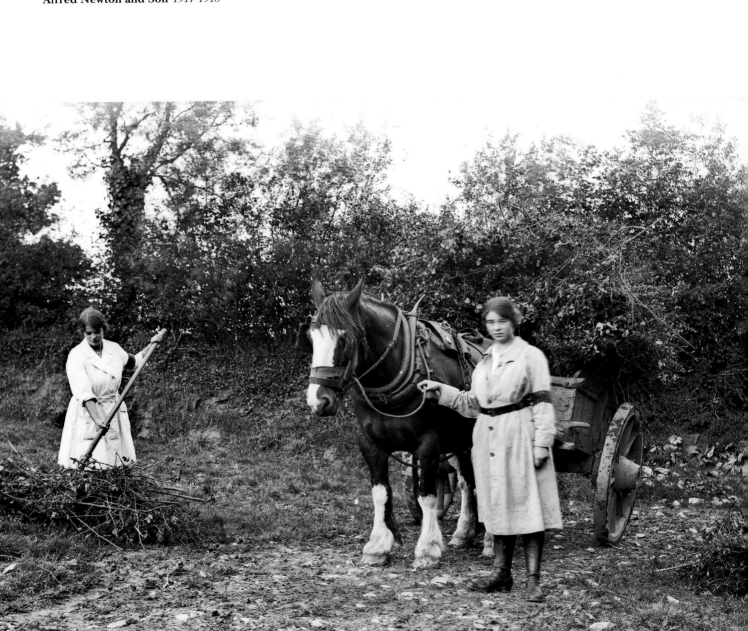

Making hutments in the carpentry section of Hamptons Munition Works, Belvedere Road, Lambeth, London.
Bedford Lemere *1916*

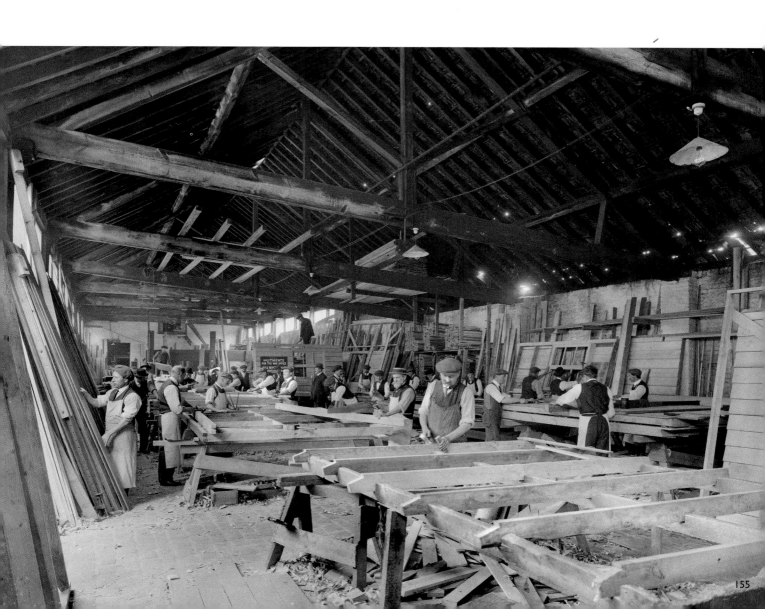

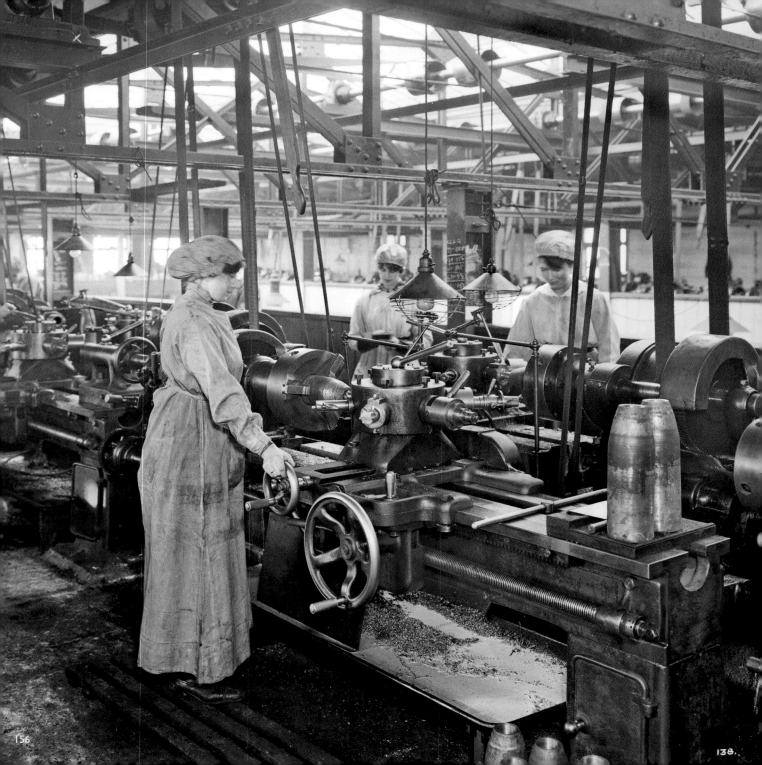

138.

Turning steel at the Cunard Shell
Works, Birkenhead, Merseyside.
Bedford Lemere *1917*

Women manufacturing shell
casings at the Cunard Shell Works,
Birkenhead, Merseyside.
Bedford Lemere *1917*

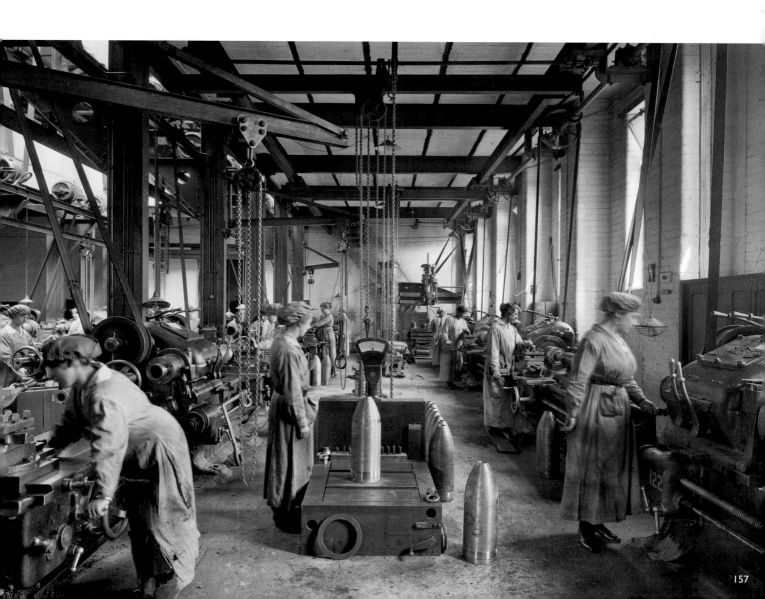

Painting shells at the Cunard Shell
Works, Birkenhead, Merseyside.
Bedford Lemere *1917*

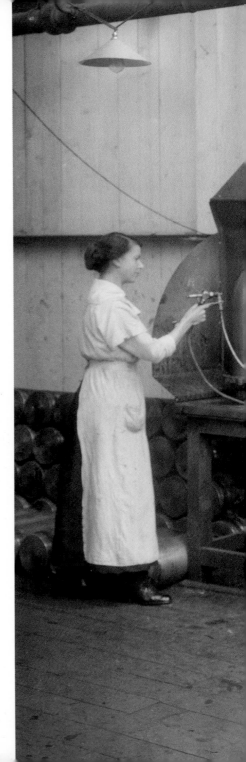

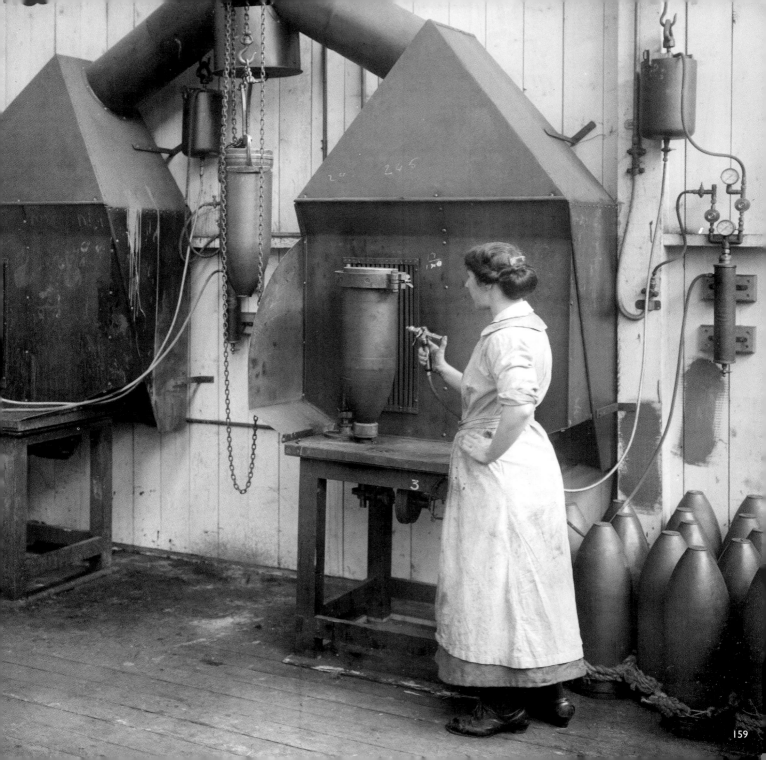

DOMESTIC
WORK

"*I WORKED in service at a big farm. My day started at 7.30 in the morning and I didn't finish while ever so late at night. No stated hours were fixed. I used to take the mistress her breakfast in bed, get on my knees with a brush and shovel and clean the carpets, feed poultry and do nearly everything myself. I got ten shillings a week and my keep but I didn't see any of it. I was allowed to take sixpence and send the rest home.*"

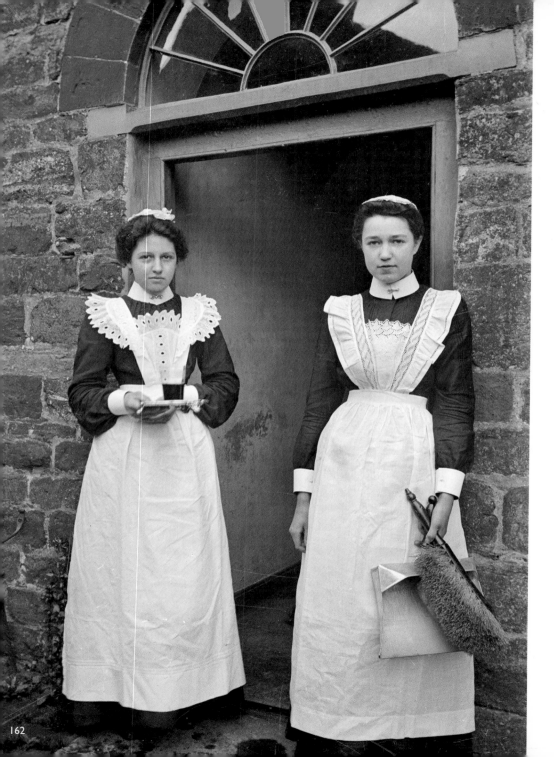

Two maids at Byfield, Northamptonshire. **Alfred Newton and Son** *1896-1920*

Servants at Pembroke College, Oxford, pose for a group photograph. **Henry Taunt** *1860-1920*

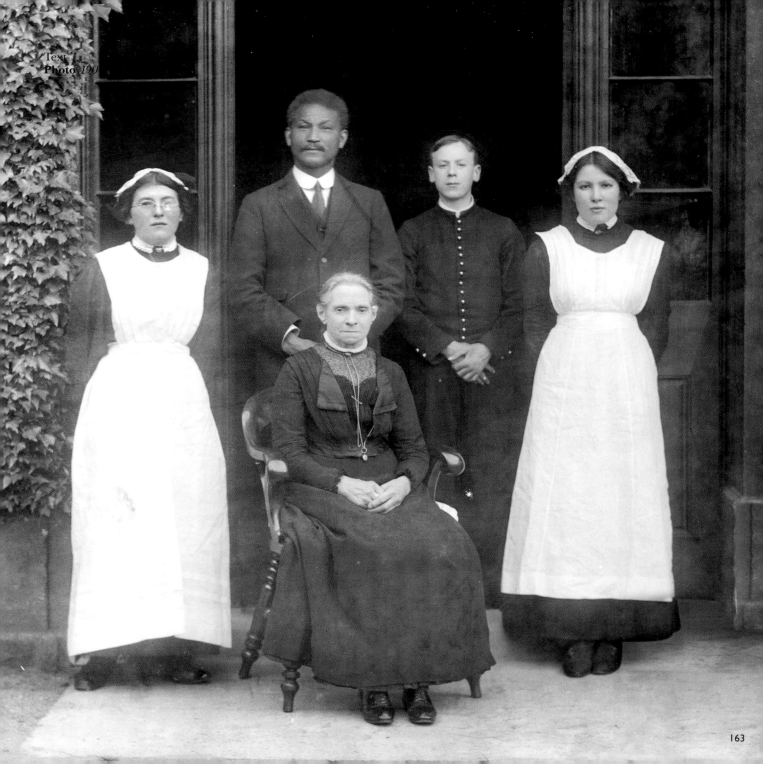

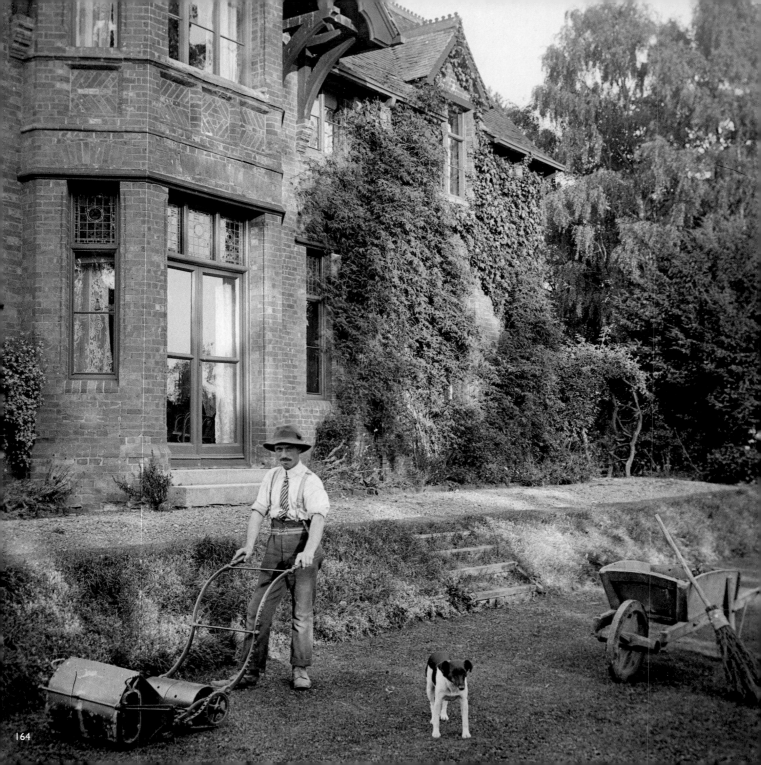

A gardener mows a lawn
in Buckinghamshire.
Alfred Newton and Son
1896-1920

A gardener uses a frame
to determine the incline
of a hedge at Great Dixter,
Northiam, East Sussex.
Nathaniel Lloyd *1919-1933*

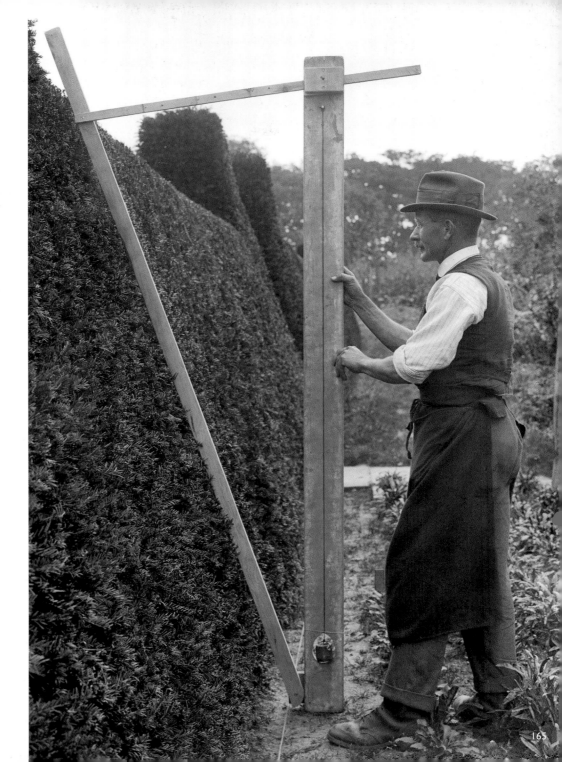

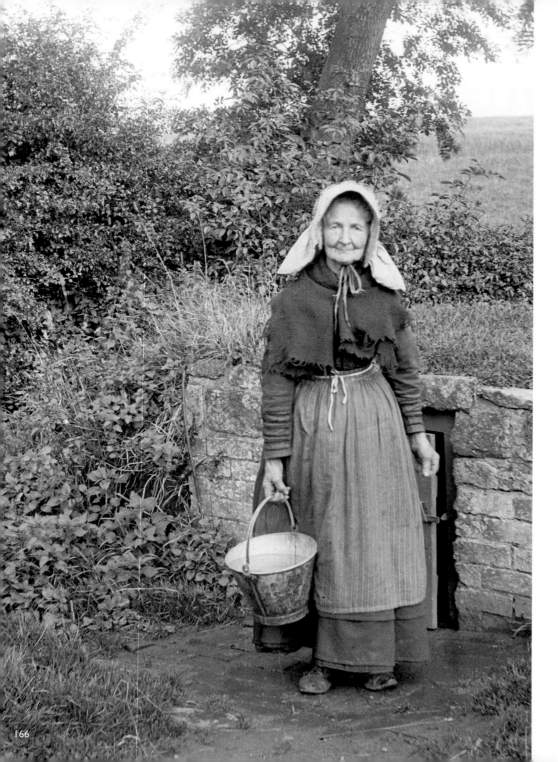

An elderly woman collects water from the village pump at Hellidon, Northamptonshire.
Alfred Newton and Son
July 1902

Bartenders at the Trocadero Restaurant, Shaftesbury Avenue, London, await their customers at the Long Bar.
Photographer unknown
c1901

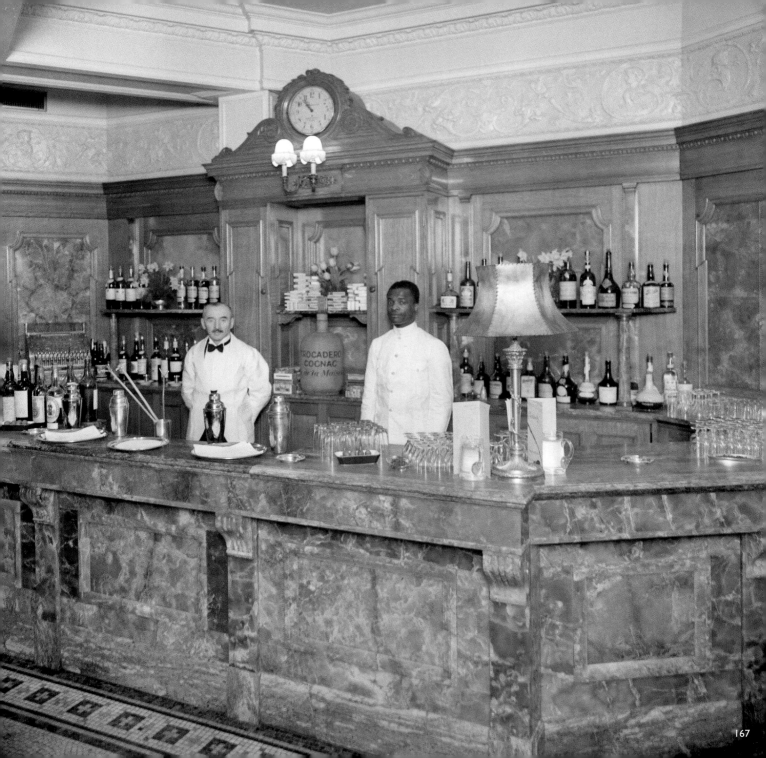

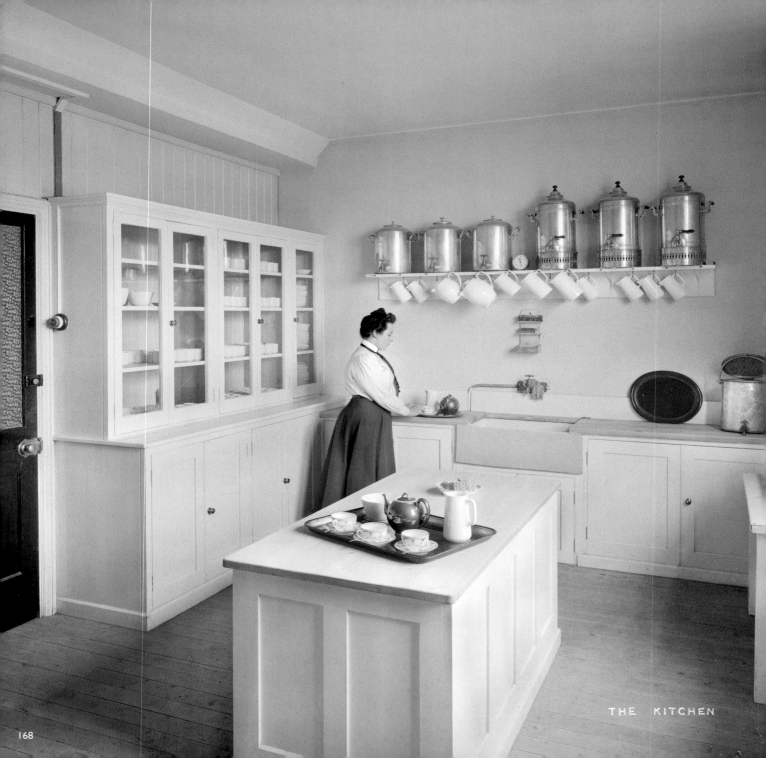

THE KITCHEN

A student prepares
for elevenses at
the International
Correspondence School,
Kingsway, London.
Bedford Lemere *1909*

A woman collects water
from a tap in a village lane
at Bratton, Somerset.
Maxwell Lyte *1890-1910*

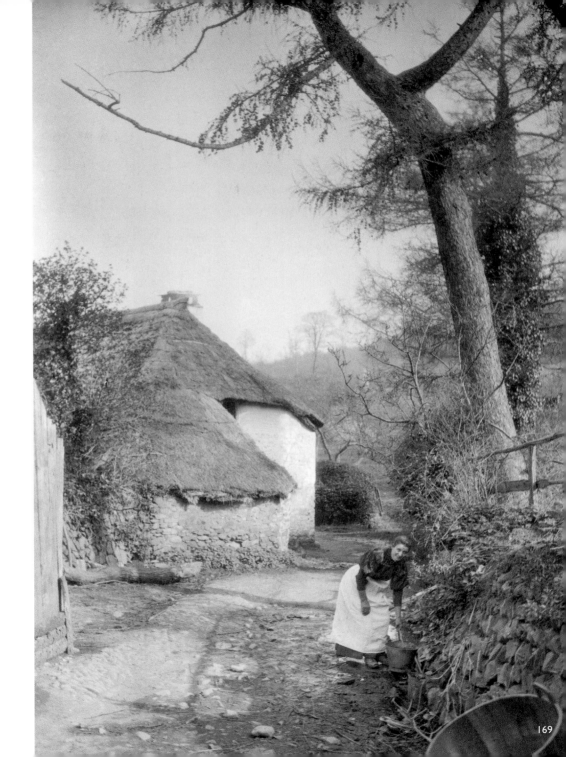

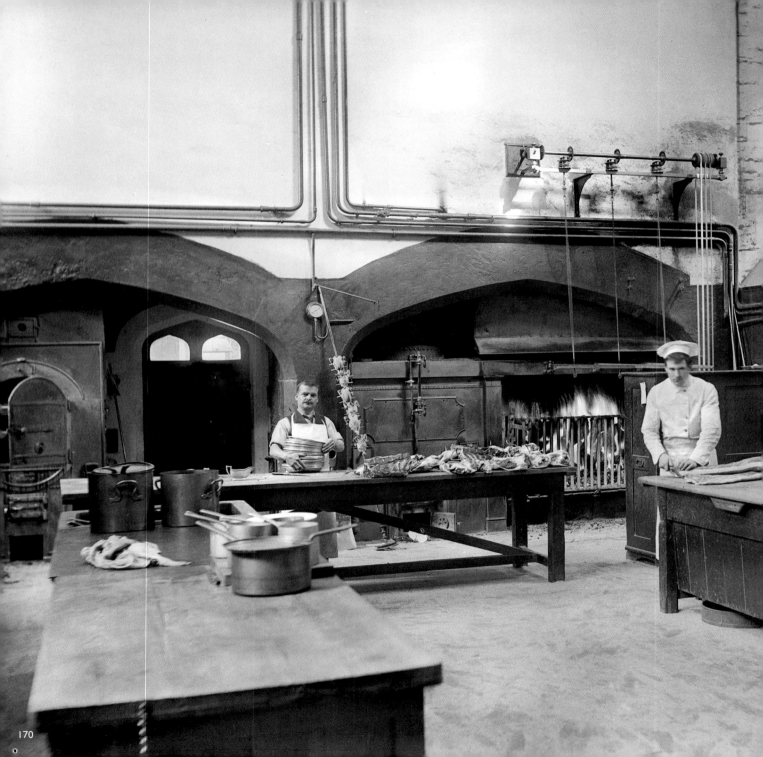

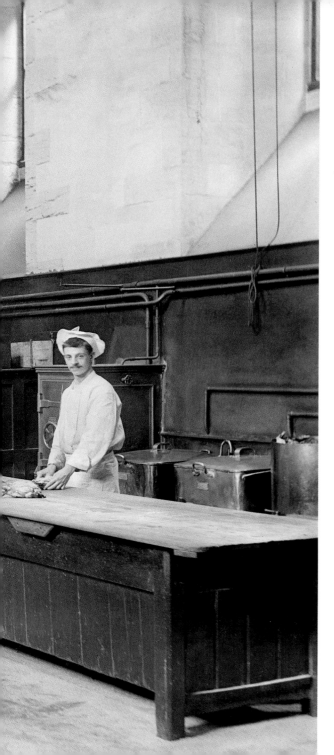

Cooks in New College
kitchen, Oxford,
Oxfordshire.
Henry Taunt *1901*

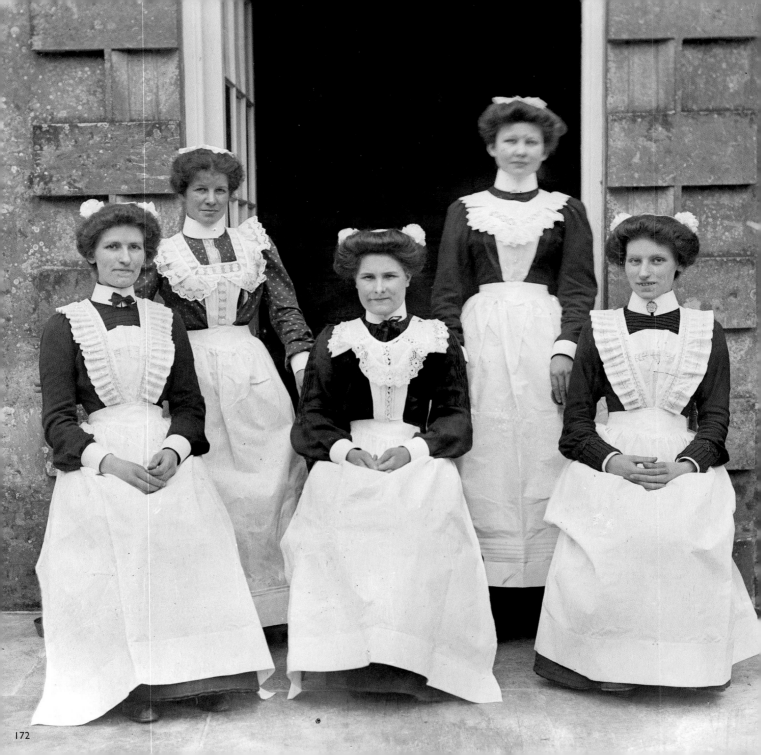

Servants at Biddlesden Park House,
Buckinghamshire.
Alfred Newton and Son *1896-1920*

The kitchen at the Tower Bridge
Hotel in Southwark, London.
Bedford Lemere *1897*

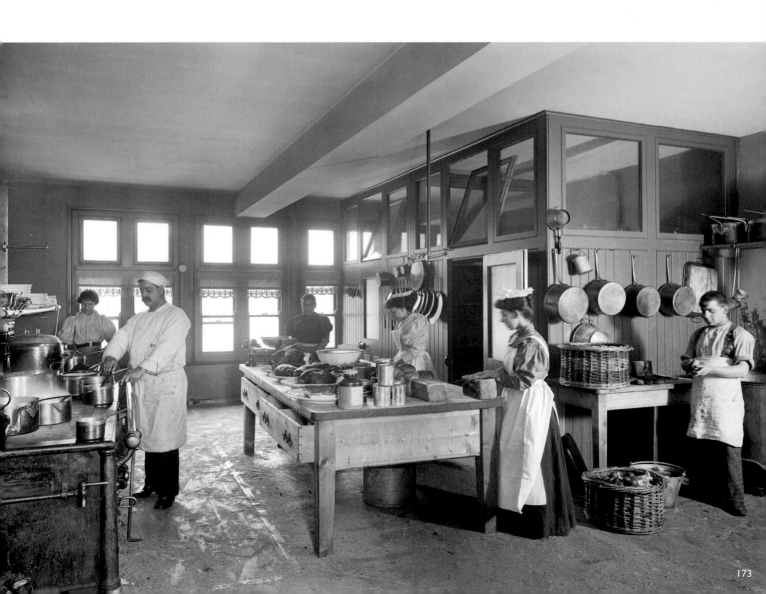

REFERENCE NUMBERS

National Monuments Record

The photographs in this book all come from the collections of the National Monuments Record (NMR).

The NMR is one of the largest publicly accessible archives in Britain and is the biggest dedicated to the historic environment. It is an unparalleled collection of images, old and new, which has been growing for over 60 years.

Set up as the National Buildings Record (NBR) in 1941 in response to the threat to historic buildings from aerial bombardment during World War II, it immediately began its own recording programme as well as collecting historic negatives and prints.

In 1963 it came under the auspices of the Royal Commission on the Historical Monuments of England and in 1999 was transferred to English Heritage. Today the collection comprises more than eight million photographs and other archive items relating to England's architecture and archaeology.

It continues to accept major collections of national importance and is a repository for material created by English Heritage's staff photographers. The collection may be consulted at the National Monuments Record office in Swindon.

Telephone 01793 414600 or email nmrinfo@english-heritage.org.uk for details.

If you would like enlargements of photographs in this book please call enquiries on 01793 414600 quoting the reference numbers on the right.